THIS BOOK
BELONGS TO

-A-SAURUS

DRAW-A

**Everything you need to know
to draw your favorite dinosaurs**

-SAURUS

JAMES SILVANI

WATSON-GUPTILL PUBLICATIONS
Berkeley

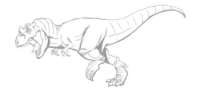
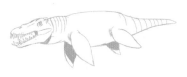
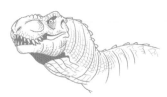

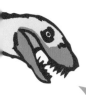

CONTENTS

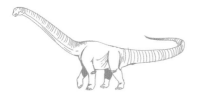
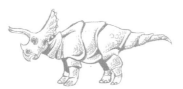
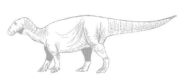

INTRODUCTION

When I was a young artist, DINOSAURS were everywhere.

Hey! I'm not *that* old!

Dinosaurs were part of my everyday life.

In the movies and television I watched . . .

In the books I read . . .

I even saw dinosaurs when I was on vacation with my family.

PRIMEVAL WORLD PRIMEVAL WORLD PRIMEVAL WORL

Dinosaurs were the most awesome things in the world. They were big, terrible monsters, and best of all, they were real!

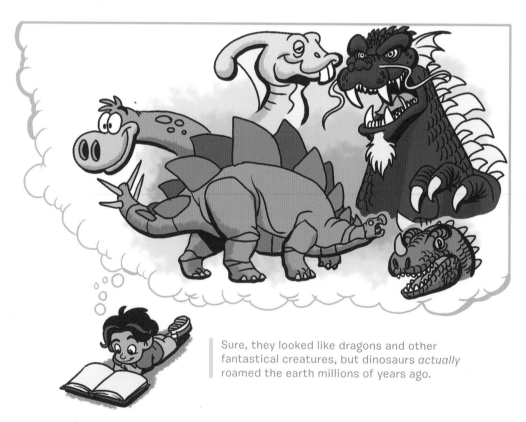

Sure, they looked like dragons and other fantastical creatures, but dinosaurs *actually* roamed the earth millions of years ago.

The word *dinosaur* means "terrible lizard." When artists first tried to re-create what dinosaurs looked like, they had only a few fossilized bones and existing lizards on which to model them.

The discovery of more bones and other fossil evidence gave us a better understanding of how dinosaurs might have appeared.

Two hundred years ago, when scientists first classified what dinosaurs were, they were thought to look very different from the picture we have of them now.

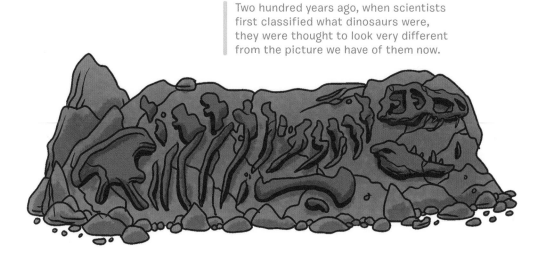

Though they were still thought of as big lizards—tail-dragging, cold-blooded slowpokes—now dinosaurs came with a variety of features.

The 1970s brought some amazing new ideas. In addition to the emergence of polyester and mood rings, scientists also discovered that dinosaurs were more closely related to birds than to lizards.

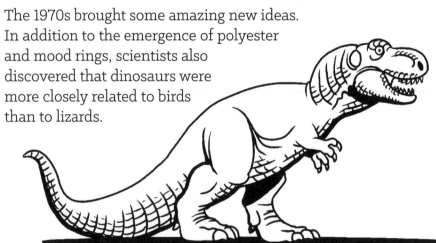

Dinosaurs were no longer slow, stupid, and cold-blooded . . .

Now they were quick, clever, and warm-blooded. Instead of dragging their tails, they held them high, helping them counterbalance their front ends for movement or defense.

They were also thought to have had sophisticated senses and complex social structures.

Some even had feathers.

I want you to throw out all the old ideas about drawing dinosaurs and try something new.

I will teach you how to go from . . .

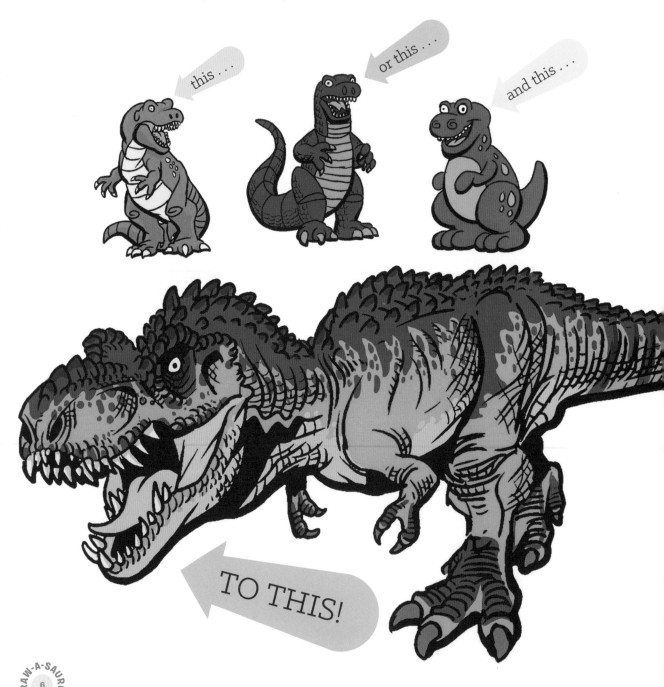

this . . .

or this . . .

and this . . .

TO THIS!

You will learn to draw dinosaurs that:

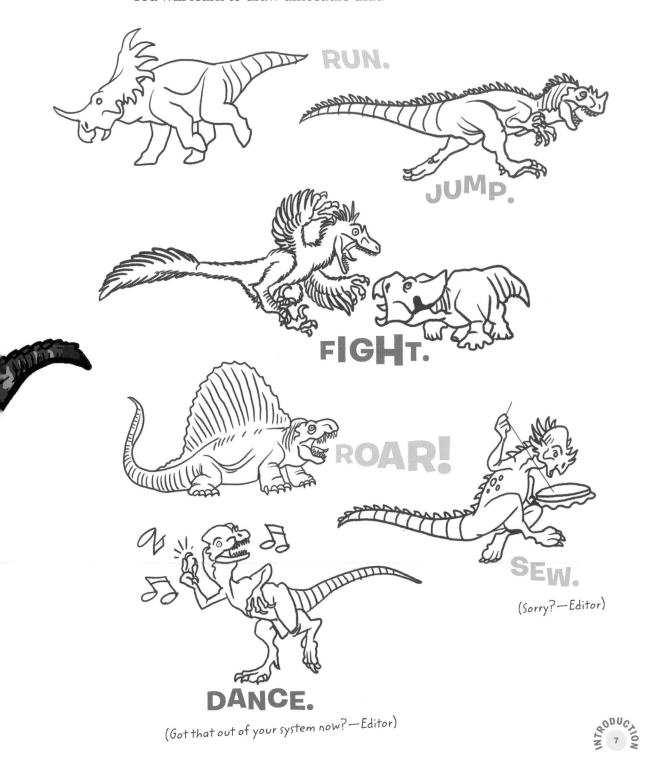

RUN.

JUMP.

FIGHT.

ROAR!

SEW.

(Sorry?—Editor)

DANCE.

(Got that out of your system now?—Editor)

CHAPTER
1

GETTING
STARTED

Before we start drawing dinosaurs, let's gather the proper tools and learn the basics of prehistoric figure drawing.

DRAWING MATERIALS

Remember: you don't want to start drawing without the right art supplies.

PAPER There's all sorts of fancy art paper and boards to draw on, but for most of my life I've drawn on 8½ x 11–inch copy paper. Make sure to use a backing (like cardboard) when you draw with inks so that it won't mess up your kitchen table.

PENCILS I always start a drawing in pencil instead of pen, because if I make a mistake, I can erase it and start over. I use a mechanical pencil that can be refilled with new leads, but a plain old #2 pencil works just as well.

ERASERS When you do make a mistake, the eraser provides your solution. Any gum or plastic eraser will do the trick. In a pinch the eraser on the tip of your #2 pencil will work, but those erasers can get used up quickly when you're starting out.

PENS Use a pen for your final line work. If you're not coloring in your work, any black fine-line pen will do. I use Pilot Fineliners for most of my doodling. If you're coloring your dinosaurs, use a permanent pen such as a Micron Pigma Liner or a Copic Multiliner.

COLORING Adding color to your drawings is a great way to bring them to life. (Well, not really "to life." These are giant lizards with really big teeth for cryin' out loud!) Crayons and colored pencils are great because they don't make a mess. Pens and markers are best for really bright colors.

ANATOMY BASICS

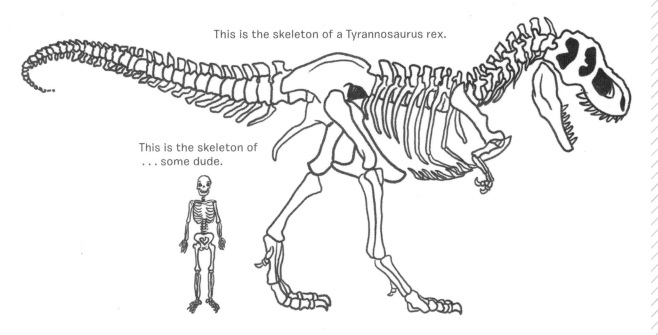

This is the skeleton of a Tyrannosaurus rex.

This is the skeleton of
. . . some dude.

As with most vertebrate animals, the two skeletons have more in common than you would think.

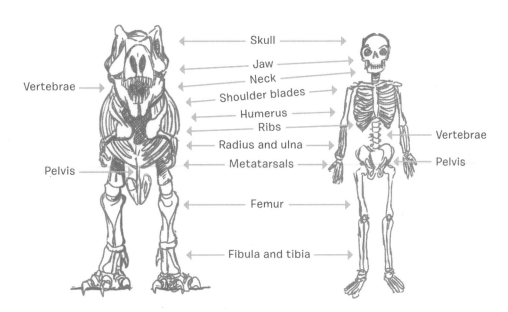

Vertebrae

Pelvis

Skull
Jaw
Neck
Shoulder blades
Humerus
Ribs
Radius and ulna
Metatarsals
Femur
Fibula and tibia

Vertebrae

Pelvis

To keep things as simple as possible, I will show you how to turn . . .

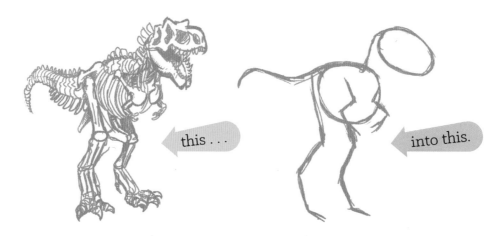

this . . . into this.

Instead of drawing 200 or so bones every time you want to sketch a T-rex, reduce the bones to simple shapes and lines that form the structure you can use to build your drawing.

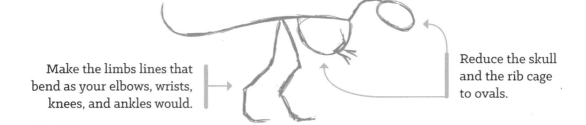

Make the limbs lines that bend as your elbows, wrists, knees, and ankles would.

Reduce the skull and the rib cage to ovals.

You can reduce the structure of any animal you want to draw to simple shapes.

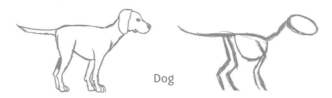

Dog

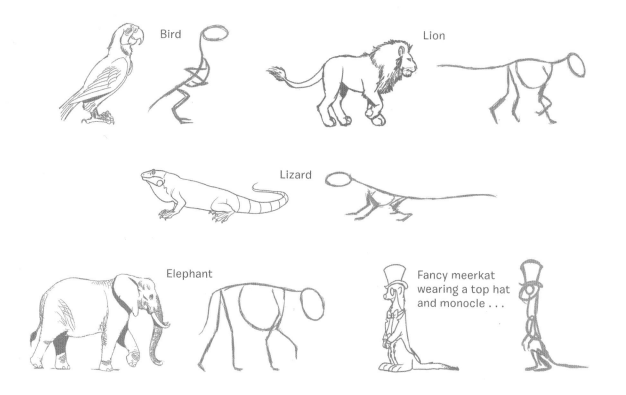

Bird

Lion

Lizard

Elephant

Fancy meerkat wearing a top hat and monocle . . .

This approach also applies to different kinds of dinosaurs…

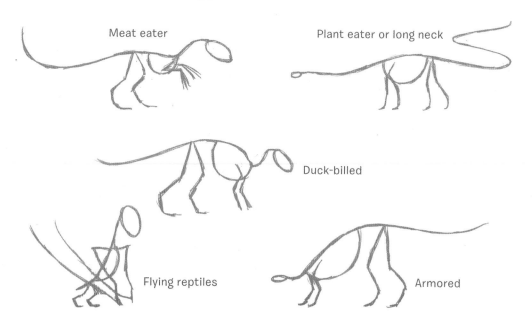

Meat eater

Plant eater or long neck

Duck-billed

Flying reptiles

Armored

DINOSAUR HIPS

The dinosaurs you will draw are divided into two branches identified by their hip bones.

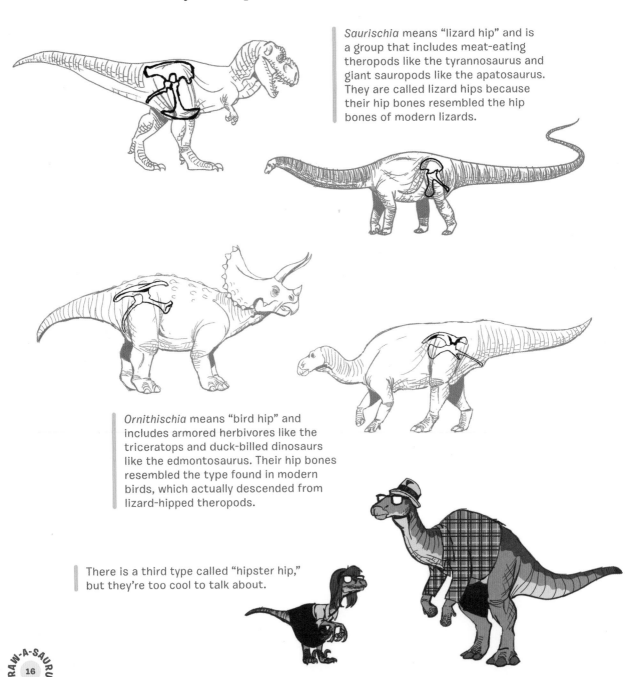

Saurischia means "lizard hip" and is a group that includes meat-eating theropods like the tyrannosaurus and giant sauropods like the apatosaurus. They are called lizard hips because their hip bones resembled the hip bones of modern lizards.

Ornithischia means "bird hip" and includes armored herbivores like the triceratops and duck-billed dinosaurs like the edmontosaurus. Their hip bones resembled the type found in modern birds, which actually descended from lizard-hipped theropods.

There is a third type called "hipster hip," but they're too cool to talk about.

DINOSAURS IN MOTION

Here's how you can give your dinosaur some action. The most common mistake artists make is starting with the dinosaur's head. If you start there, you can run out of room for the rest of the dinosaur very quickly. Look back at the simple structures on page 15. The lines that represent the vertebrae are the largest parts of these sketches. *Start* with that line.

Imagine different actions for the dinosaur. Use a single line that fits within the confines of your sheet of paper to represent that action. Leave just a bit of room for the dinosaur's head.

Try drawing your dinosaur performing different actions, such as . . .

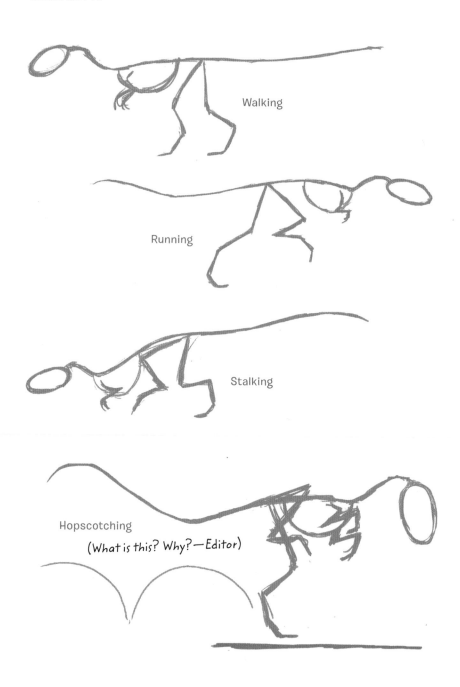

Walking

Running

Stalking

Hopscotching

(What is this? Why? —Editor)

If you need a little help with your drawing, have someone model for you.

Remember the similarities between a human's body and a dinosaur's? Have a friend or a parent pose as a dinosaur for you to draw from.

Just add the tail.

If you can get a bird to sit still long enough, it can make an excellent model for a smaller theropod. (For more on theropods, see chapter 2.)

If you want to draw a dinosaur that walks on all fours, look at your dog or cat.

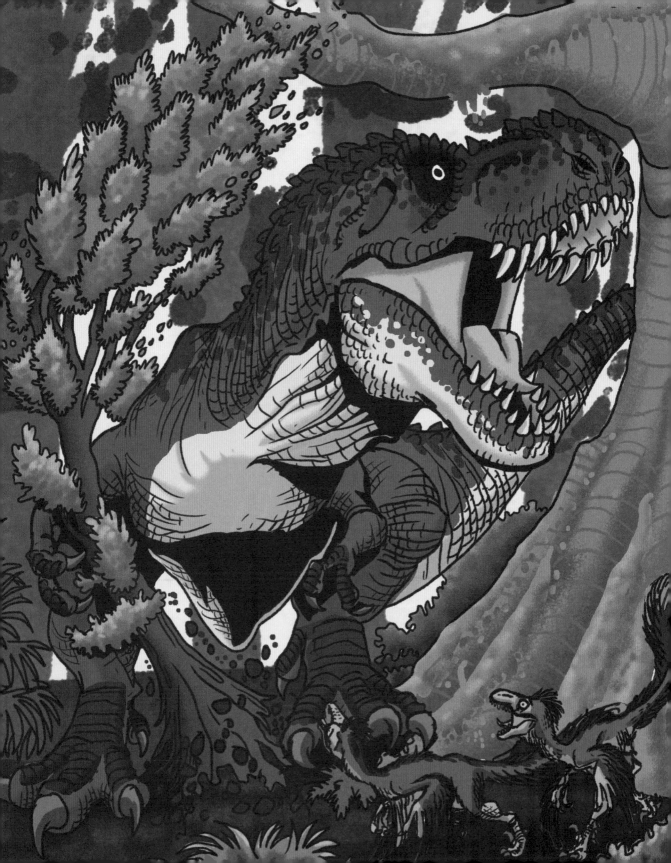

CHAPTER 2

DRAWING THEROPODS

THEROPODS
were **TWO-LEGGED MEAT-EATING** dinosaurs
characterized by **S-SHAPED NECKS** and
SHORT ARMS.

DRAW THE
TYRANNOSAURUS REX

Let's start with the most famous theropod of all–Tyrannosaurus rex! It lived 67 million to 65 million years ago in what is now North America. The average T-rex was 43 feet long and 13 feet high and weighed up to 7.5 tons.

 DINO-FACT

The head of an average T-rex was 5 feet long.

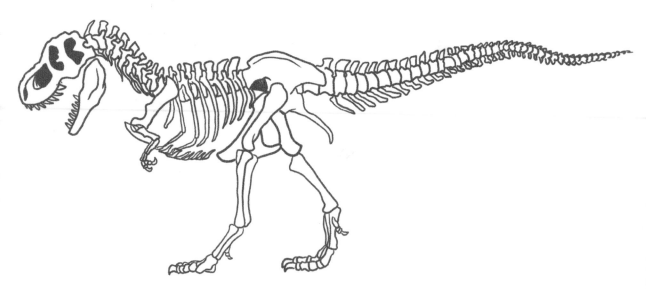

Take the skeleton on the previous page and reduce it to its most basic shapes.

Start with a curving line for the spinal column.

Add a simple oval for the head.

Add the legs. |—→

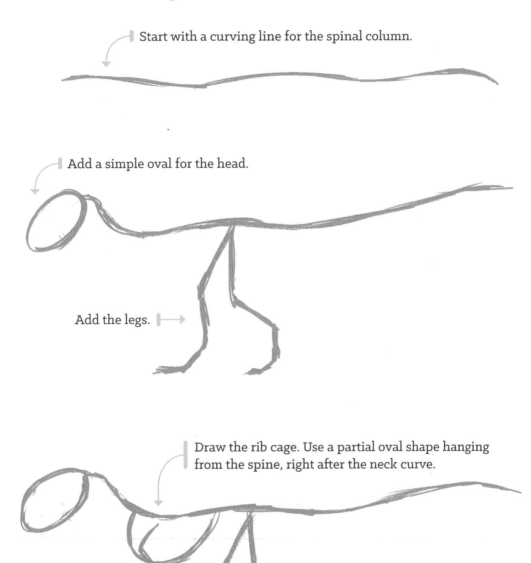

Draw the rib cage. Use a partial oval shape hanging from the spine, right after the neck curve.

Draw the T-rex's tiny arms and connect them near the front of the ribs.

ADD TO THE TYRANNOSAURUS

Lightly sketch the oval shapes.

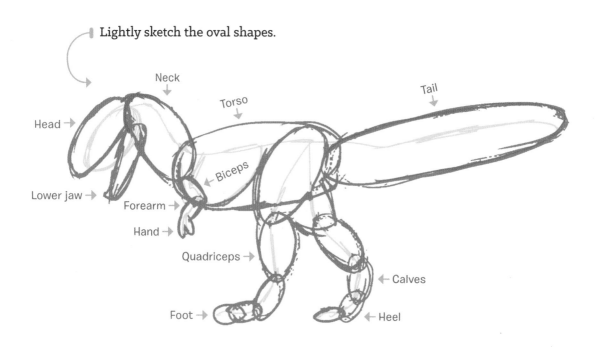

Neck

Torso

Tail

Head →

← Biceps

Lower jaw →

Forearm →

Hand →

Quadriceps →

← Calves

Foot →

← Heel

Draw a heavier line to outline the body. Adjust for form and function.

Taper the tail at its end.

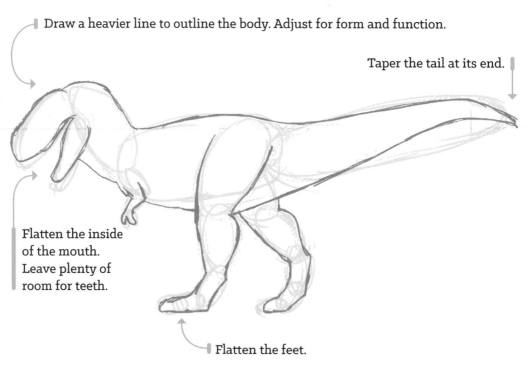

Flatten the inside
of the mouth.
Leave plenty of
room for teeth.

Flatten the feet.

FLESH OUT THE TYRANNOSAURUS

Notice the ridge of bone that protects the eye.

Make the neck very thick and muscular.

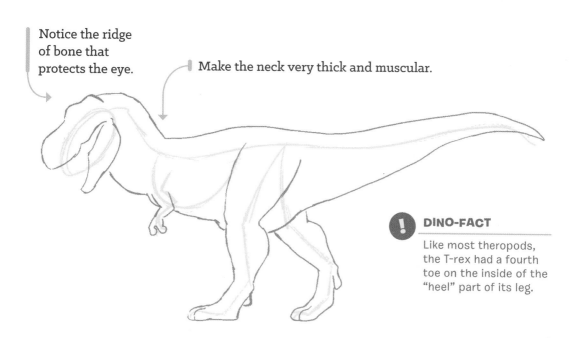

! DINO-FACT

Like most theropods, the T-rex had a fourth toe on the inside of the "heel" part of its leg.

Add forward-facing eyes that are always watching you.

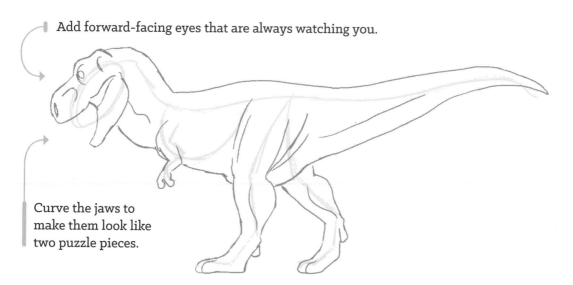

Curve the jaws to make them look like two puzzle pieces.

Draw the skull so that you see its impressions through the skin.

Use visible segments on the neck and tail to show flexibility.

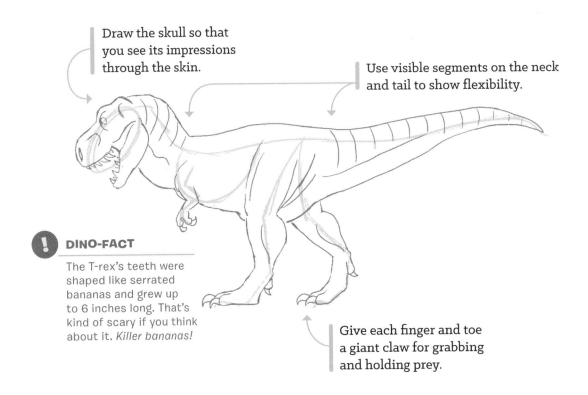

! DINO-FACT

The T-rex's teeth were shaped like serrated bananas and grew up to 6 inches long. That's kind of scary if you think about it. *Killer bananas!*

Give each finger and toe a giant claw for grabbing and holding prey.

Notice the bony ridges used to protect the skull.

Add thick, scaly folds of skin.

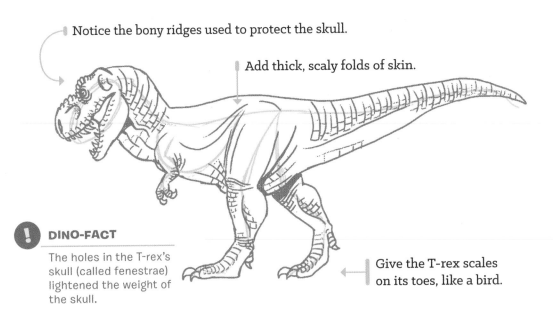

! DINO-FACT

The holes in the T-rex's skull (called fenestrae) lightened the weight of the skull.

Give the T-rex scales on its toes, like a bird.

BRING THE TYRANNOSAURUS TO LIFE

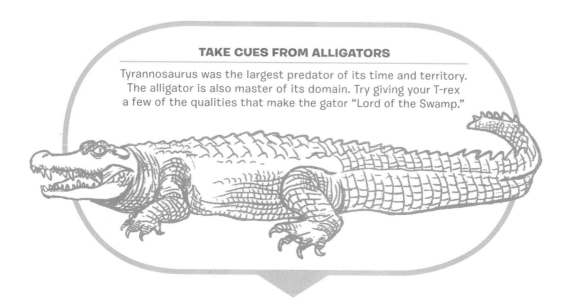

TAKE CUES FROM ALLIGATORS

Tyrannosaurus was the largest predator of its time and territory. The alligator is also master of its domain. Try giving your T-rex a few of the qualities that make the gator "Lord of the Swamp."

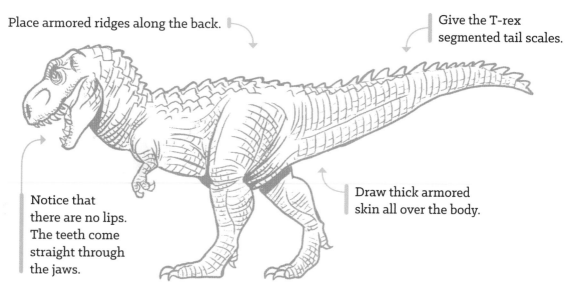

Place armored ridges along the back.

Give the T-rex segmented tail scales.

Notice that there are no lips. The teeth come straight through the jaws.

Draw thick armored skin all over the body.

TAKE CUES FROM BIRDS

These days it's a given that dinosaurs evolved into birds. It's also becoming more and more evident that some dinosaurs actually had feathers. During the late Cretaceous period, the tyrannosaurus was the largest predator. In the world of modern birds, the eagle rules the skies. The T-rex might have had features similar to the eagle's.

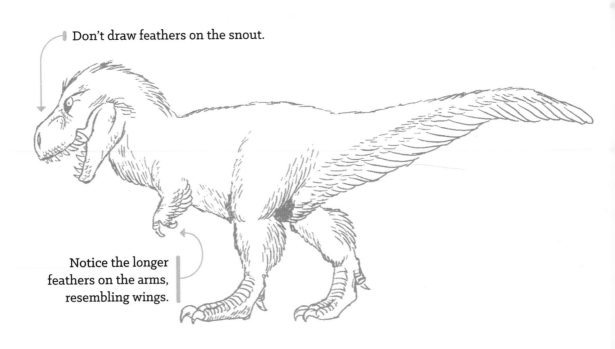

Don't draw feathers on the snout.

Notice the longer feathers on the arms, resembling wings.

GIVE THE TYRANNOSAURUS SOME COLOR

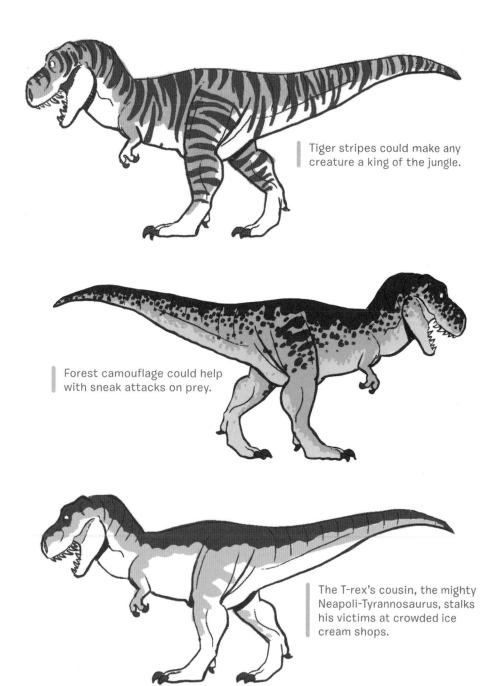

Tiger stripes could make any creature a king of the jungle.

Forest camouflage could help with sneak attacks on prey.

The T-rex's cousin, the mighty Neapoli-Tyrannosaurus, stalks his victims at crowded ice cream shops.

ANGLES AND GESTURES

Practice drawing the tyrannosaurus from different angles:

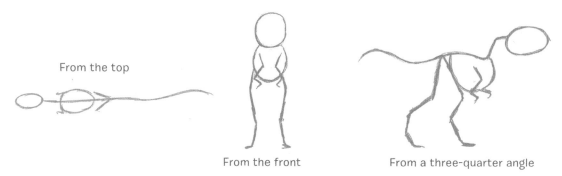

From the top

From the front

From a three-quarter angle

Now add some action:

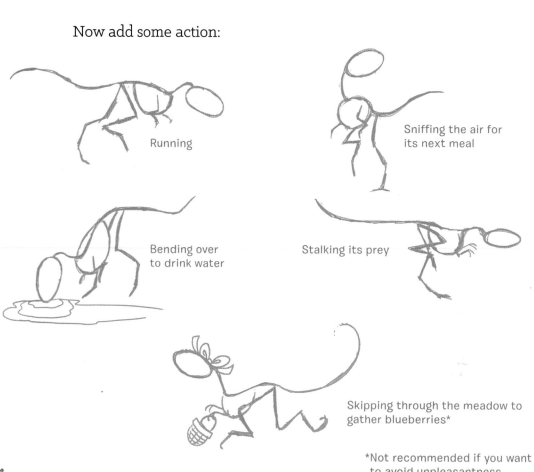

Running

Sniffing the air for
its next meal

Bending over
to drink water

Stalking its prey

Skipping through the meadow to
gather blueberries*

*Not recommended if you want
to avoid unpleasantness.

Finalizing Gesture Drawings

Now bring your gesture drawings to life:

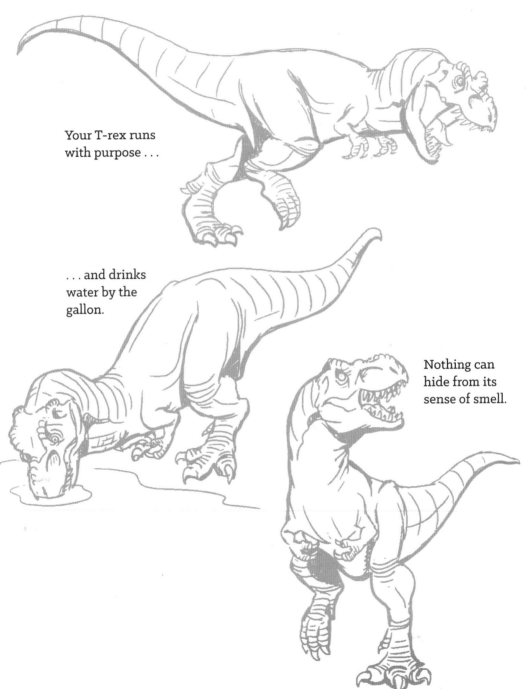

Your T-rex runs with purpose . . .

. . . and drinks water by the gallon.

Nothing can hide from its sense of smell.

It stalks its prey through the forests and other terrain.

It merrily skips through the blueberry fields.

(I thought we discussed this. No skipping!—Editor)

It ravenously sips a blueberry smoothie.

(Will you stop?!?!—Editor)

It ferociously scrapbooks about a day of blueberry picking.

(T-rex does not eat blueberries!—Editor)

T-REX PARTS

The T-rex's head was its main weapon. It was thick, solid, and dangerous (even without a mouth full of teeth).

It also had a thin snout that didn't get in the way of its field of vision.

Unlike most theropods or even modern lizards, the T-rex had forward-facing eyes so that it could see farther and wider.

A tyrannosaur's tail was thick and rigid. Not only did the T-rex's tail balance its front half, it also acted like a rudder. The tyrannosaur's tail could bend a bit, but it could not curl or twist like a cat's.

The T-rex's tiny arms and two fingers had a limited range of movement. Although they were useful for holding down prey, they had little function in actual hunting.

When the tyrannosaurus's foot was on the ground, its toes splayed outward. When its foot was lifted for running or walking, the toes came together.

DRAWING OTHER
THEROPODS

Although they all had S-curved necks, short arms, and long balancing tails, theropods came in all shapes and sizes.

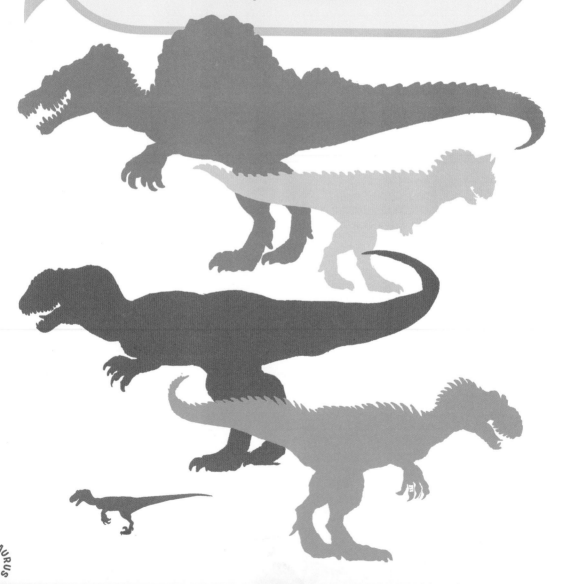

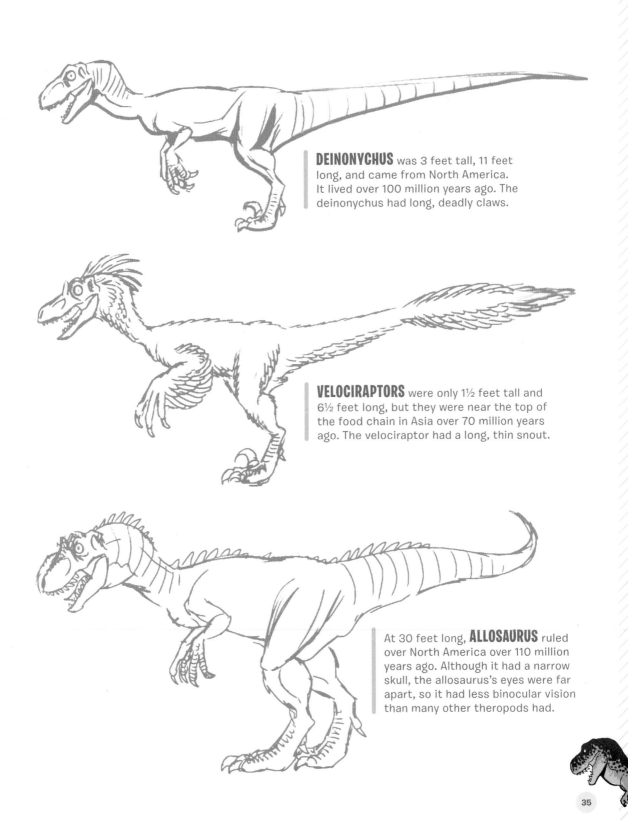

DEINONYCHUS was 3 feet tall, 11 feet long, and came from North America. It lived over 100 million years ago. The deinonychus had long, deadly claws.

VELOCIRAPTORS were only 1½ feet tall and 6½ feet long, but they were near the top of the food chain in Asia over 70 million years ago. The velociraptor had a long, thin snout.

At 30 feet long, **ALLOSAURUS** ruled over North America over 110 million years ago. Although it had a narrow skull, the allosaurus's eyes were far apart, so it had less binocular vision than many other theropods had.

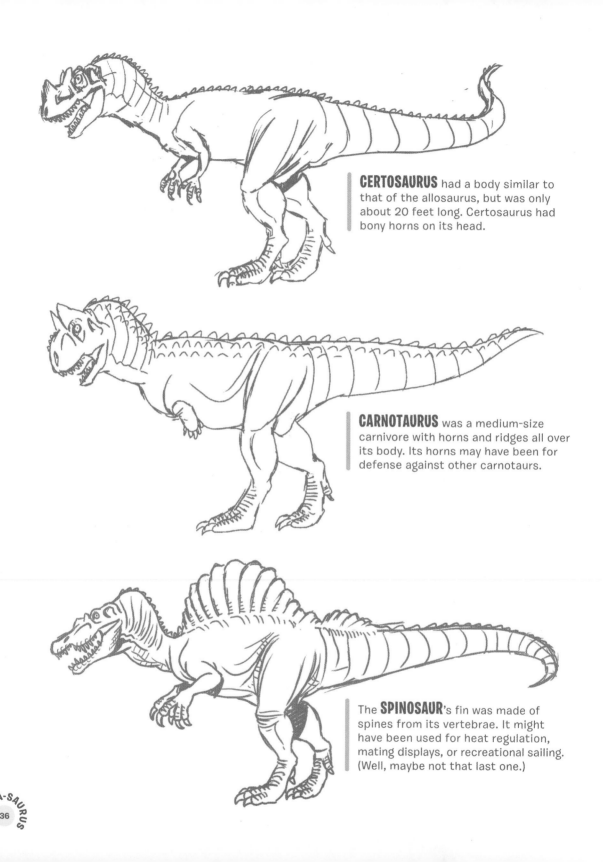

CERTOSAURUS had a body similar to that of the allosaurus, but was only about 20 feet long. Certosaurus had bony horns on its head.

CARNOTAURUS was a medium-size carnivore with horns and ridges all over its body. Its horns may have been for defense against other carnotaurs.

The **SPINOSAUR**'s fin was made of spines from its vertebrae. It might have been used for heat regulation, mating displays, or recreational sailing. (Well, maybe not that last one.)

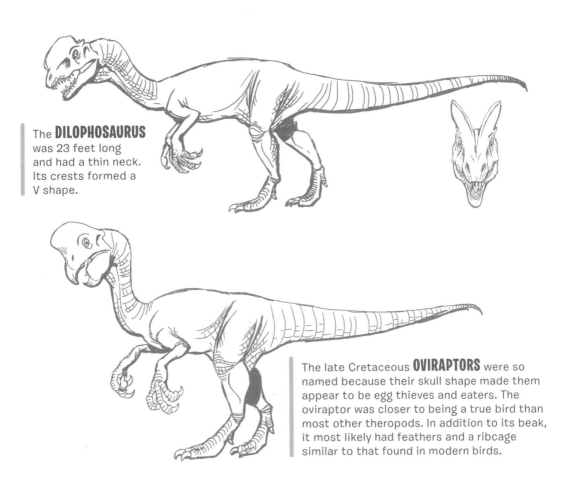

The **DILOPHOSAURUS** was 23 feet long and had a thin neck. Its crests formed a V shape.

The late Cretaceous **OVIRAPTORS** were so named because their skull shape made them appear to be egg thieves and eaters. The oviraptor was closer to being a true bird than most other theropods. In addition to its beak, it most likely had feathers and a ribcage similar to that found in modern birds.

The **CRYOLOPHOSAURUS** was discovered in Antarctica. The bone on its head gave the appearance of a pompadour hairstyle. Scientists are still looking for evidence of cryolophosaurus riding motorcycles or wearing leather jackets.

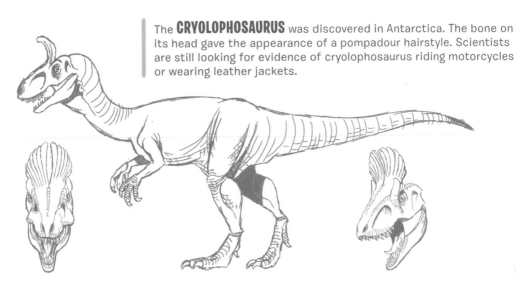

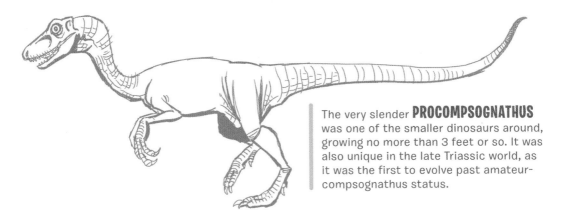

The very slender **PROCOMPSOGNATHUS** was one of the smaller dinosaurs around, growing no more than 3 feet or so. It was also unique in the late Triassic world, as it was the first to evolve past amateur-compsognathus status.

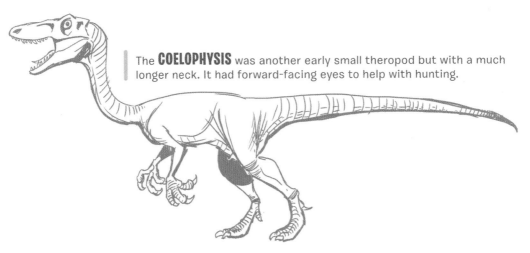

The **COELOPHYSIS** was another early small theropod but with a much longer neck. It had forward-facing eyes to help with hunting.

ARCHAEOPTERYX is considered the link between dinosaurs and birds. Although many theropods are now thought to have had feathers, archaeopteryx was the first dinosaur capable of some sort of flight.

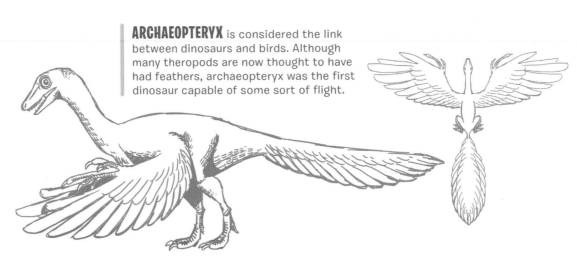

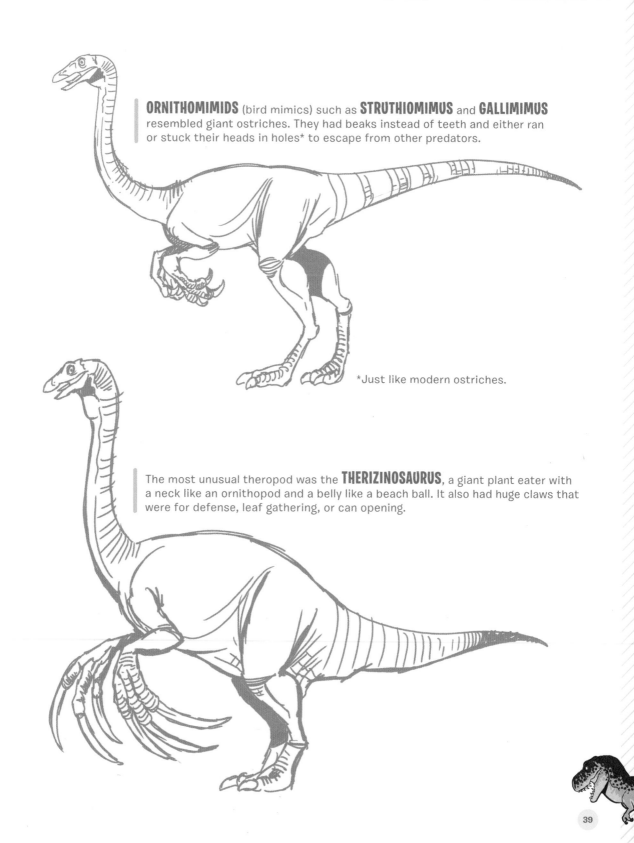

ORNITHOMIMIDS (bird mimics) such as **STRUTHIOMIMUS** and **GALLIMIMUS** resembled giant ostriches. They had beaks instead of teeth and either ran or stuck their heads in holes* to escape from other predators.

*Just like modern ostriches.

The most unusual theropod was the **THERIZINOSAURUS**, a giant plant eater with a neck like an ornithopod and a belly like a beach ball. It also had huge claws that were for defense, leaf gathering, or can opening.

DRAWING
SAUROPODS

SAUROPODS
were the **TRUE GIANTS** of the
DINOSAUR world. Characterized
by their **LONG NECKS AND TAILS,**
these **FOUR-FOOTED** dinosaurs
could reach up to **100 TONS.**

DRAW THE
APATOSAURUS

The apatosaurus had the most common sauropod shape. The average apatosaurus was a Jurassic dinosaur that reached 75 feet in length and weighed up to 39 tons.

! DINO-FACT

Unlike that of a theropod, the sauropod's head was very small relative to its body.

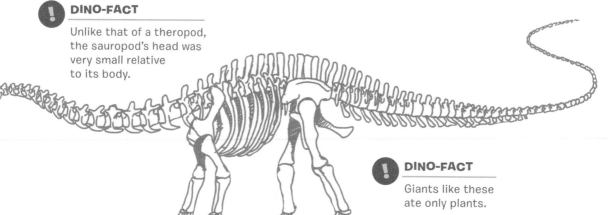

! DINO-FACT

Giants like these ate only plants.

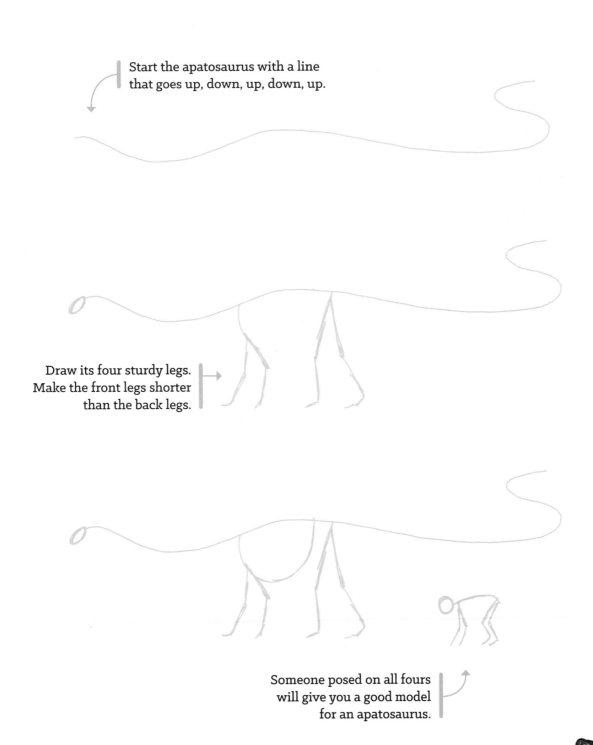

Start the apatosaurus with a line
that goes up, down, up, down, up.

Draw its four sturdy legs.
Make the front legs shorter
than the back legs.

Someone posed on all fours
will give you a good model
for an apatosaurus.

ADD TO THE APATOSAURUS

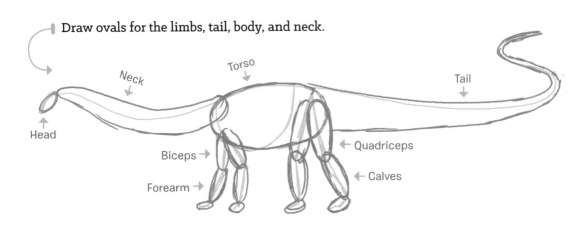

Draw ovals for the limbs, tail, body, and neck.

Neck

Torso

Tail

Head

Biceps

Quadriceps

Forearm

Calves

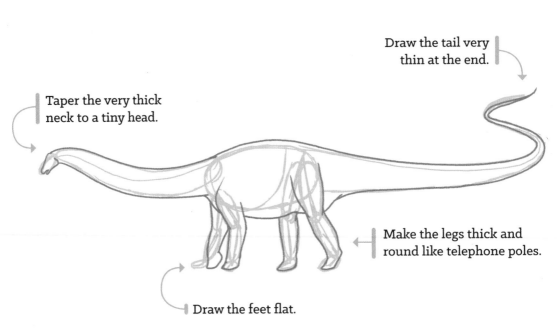

Draw the tail very thin at the end.

Taper the very thick neck to a tiny head.

Make the legs thick and round like telephone poles.

Draw the feet flat.

FLESH OUT THE APATOSAURUS

! **DINO-FACT**

As with most prehistoric herbivores, the apatosaurus's mouth was used for gathering food. The chewing took place elsewhere.

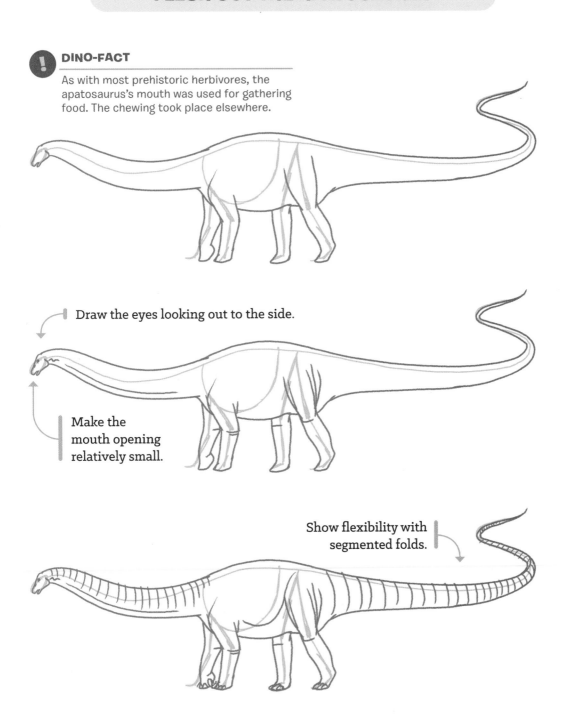

Draw the eyes looking out to the side.

Make the mouth opening relatively small.

Show flexibility with segmented folds.

BRING THE APATOSAURUS TO LIFE

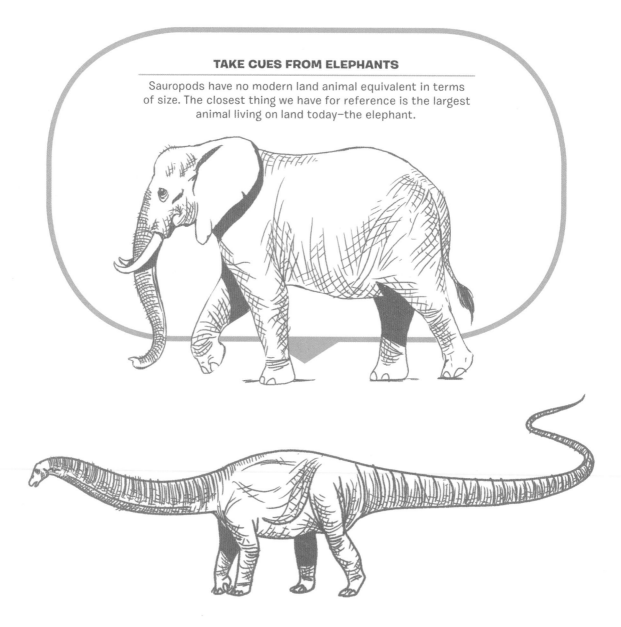

TAKE CUES FROM ELEPHANTS

Sauropods have no modern land animal equivalent in terms of size. The closest thing we have for reference is the largest animal living on land today–the elephant.

GIVE THE APATOSAURUS SOME COLOR

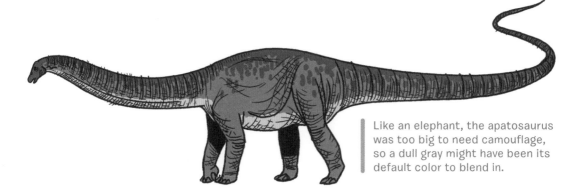

Like an elephant, the apatosaurus was too big to need camouflage, so a dull gray might have been its default color to blend in.

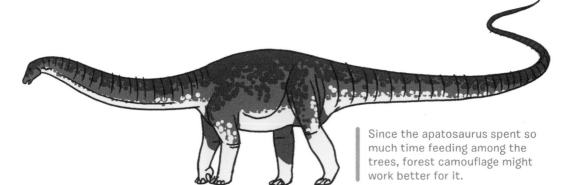

Since the apatosaurus spent so much time feeding among the trees, forest camouflage might work better for it.

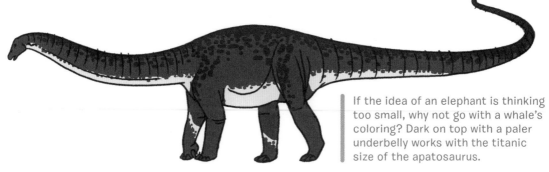

If the idea of an elephant is thinking too small, why not go with a whale's coloring? Dark on top with a paler underbelly works with the titanic size of the apatosaurus.

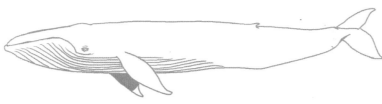

ANGLES AND GESTURES

Practice sketching the apatosaurus from different angles.

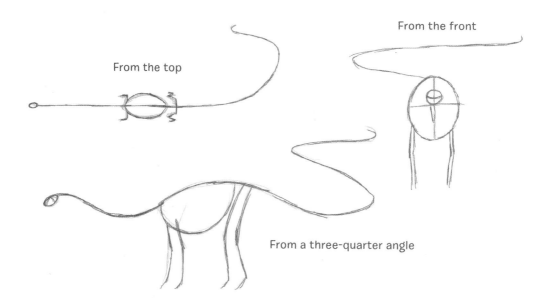

From the top

From the front

From a three-quarter angle

I would normally say that this would be a good time to draw an apatosaur in action, but paleontologists figured that all they did was eat and walk to their next meal.

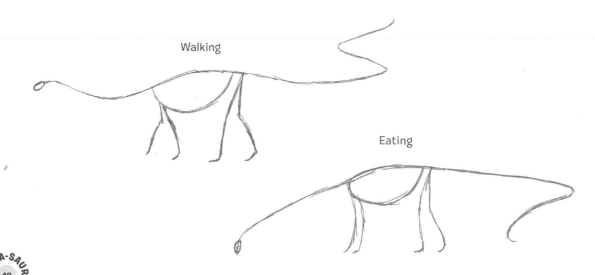

Walking

Eating

Finalizing Gesture Drawings

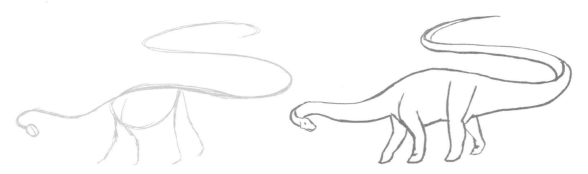

A sauropod that felt threatened could use its tail as a whip and send a predator into next week.

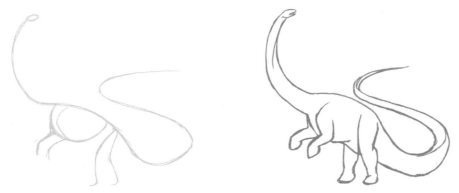

Because of their immobile necks, sauropods would rear up on their hind legs to reach the leaves on taller trees (or to win at Twister).

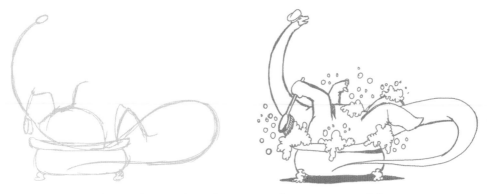

In the past, paleontologists thought sauropods spent most of their time in water to support their vast weight. Now it is clear that they spent most of their time on land, venturing to the water mostly to drink and bathe.

APATOSAURUS PARTS

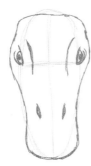

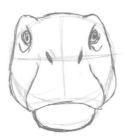

Although the head is tiny, it still has details. Apatosaurus's nostrils were on the top of its head.

Its eyes pointed out on either side of the head.

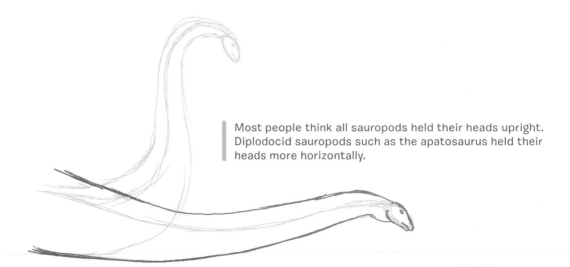

Most people think all sauropods held their heads upright. Diplodocid sauropods such as the apatosaurus held their heads more horizontally.

The tail of the apatosaurus was the longest of any animal. It's thought that it could be used defensively as a whip or as a tickling device.

DRAWING OTHER
SAUROPODS

Sauropods were the largest creature ever to have lived on the planet earth, with some even eclipsing the mighty blue whale, the largest creature living today.

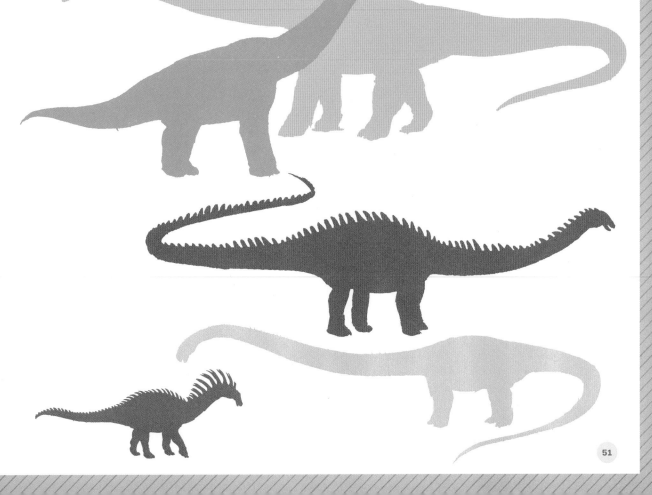

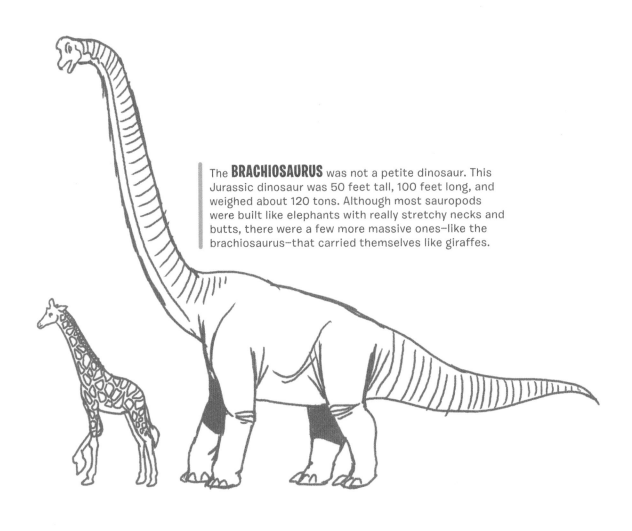

The **BRACHIOSAURUS** was not a petite dinosaur. This Jurassic dinosaur was 50 feet tall, 100 feet long, and weighed about 120 tons. Although most sauropods were built like elephants with really stretchy necks and butts, there were a few more massive ones—like the brachiosaurus—that carried themselves like giraffes.

DIPLODOCUS is a Jurassic sauropod that was at one time believed to be the longest dinosaur. It's thought that neural spines (like the ones shown here) ran along the entire length of the diplodocus.

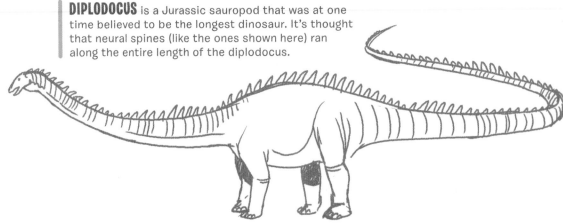

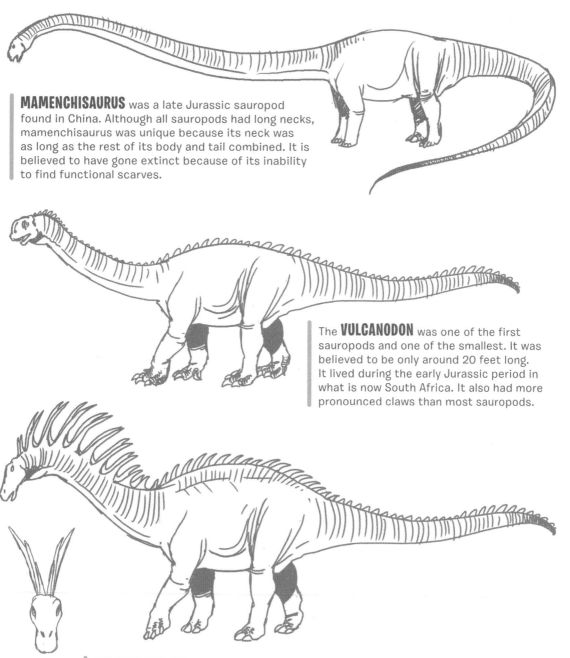

MAMENCHISAURUS was a late Jurassic sauropod found in China. Although all sauropods had long necks, mamenchisaurus was unique because its neck was as long as the rest of its body and tail combined. It is believed to have gone extinct because of its inability to find functional scarves.

The **VULCANODON** was one of the first sauropods and one of the smallest. It was believed to be only around 20 feet long. It lived during the early Jurassic period in what is now South Africa. It also had more pronounced claws than most sauropods.

AMARGASAURUS was an early Cretaceous dinosaur that lived in South America. It was on the small side of the sauropod family, but what made it stand out were the twin sets of spines that grew from its neck and back. It was once thought the spines supported a sail running the length of its neck. The twin sets of spines formed a V shape. Or a dino peace sign. Take your pick.

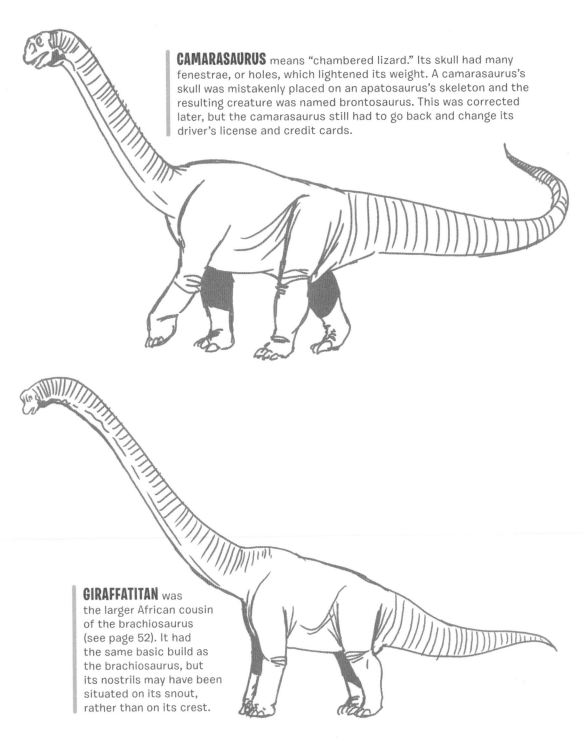

CAMARASAURUS means "chambered lizard." Its skull had many fenestrae, or holes, which lightened its weight. A camarasaurus's skull was mistakenly placed on an apatosaurus's skeleton and the resulting creature was named brontosaurus. This was corrected later, but the camarasaurus still had to go back and change its driver's license and credit cards.

GIRAFFATITAN was the larger African cousin of the brachiosaurus (see page 52). It had the same basic build as the brachiosaurus, but its nostrils may have been situated on its snout, rather than on its crest.

The **SALTASAURUS** was another sauropod from South America and one of the few armored long-necks ever discovered. It averaged 40 feet long and weighed 8 tons. It came from a group of sauropods called titanosaurs. The saltasaurus's back was covered in individual plates and set with bony nodules.

ARGENTINOSAURUS is thought to be the largest animal ever to walk the earth. This titanosaur might have been up to 120 feet long and might have weighed up to 110 tons.

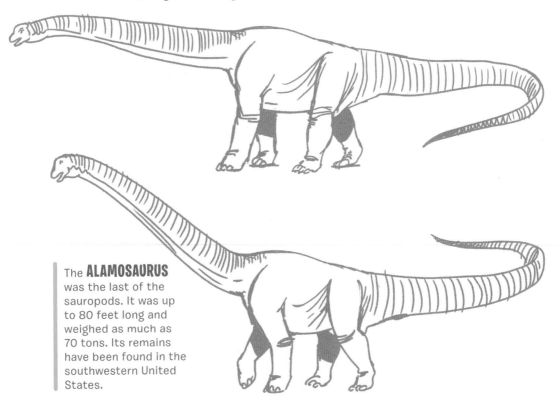

The **ALAMOSAURUS** was the last of the sauropods. It was up to 80 feet long and weighed as much as 70 tons. Its remains have been found in the southwestern United States.

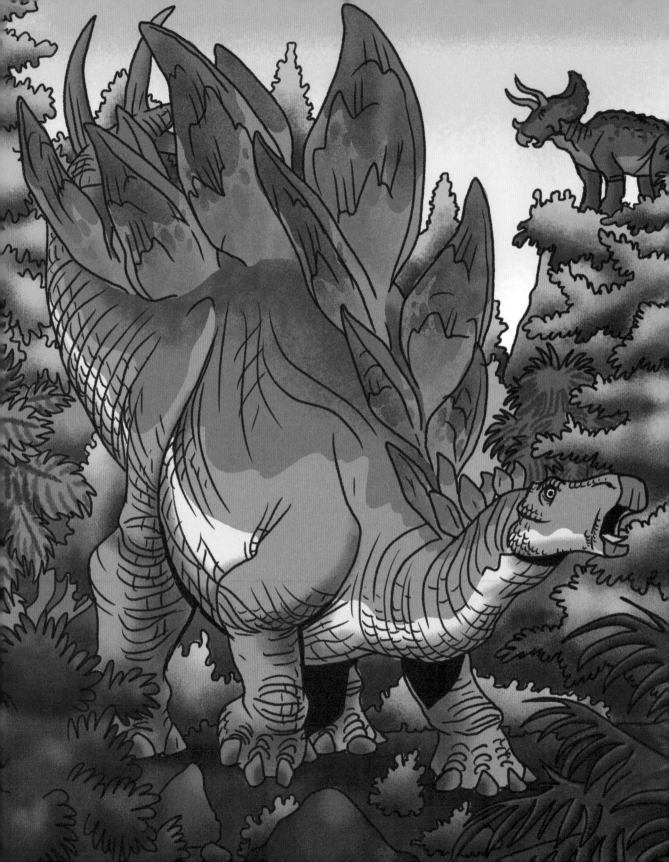

CHAPTER 4

DRAWING ARMORED DINOSAURS

Now it's time to draw some **ORNITHISCHIAN,** or "BIRD-HIPPED," dinosaurs. The examples here are all **FOUR-LEGGED BEAKED HERBIVORES,** and they are all packin' heat! Each one had a **BUILT-IN SECURITY SYSTEM** that would make any predator cry for its mommy.

These bad mamma jammas are divided into three types:

CERATOPSIANS (like the triceratops), **ANKYLOSAURS**, and **STEGOSAURS**.

DRAW THE
TRICERATOPS

Ceratopsians all had bony frills at the back of their skulls and faces full of horns to really get their point across.

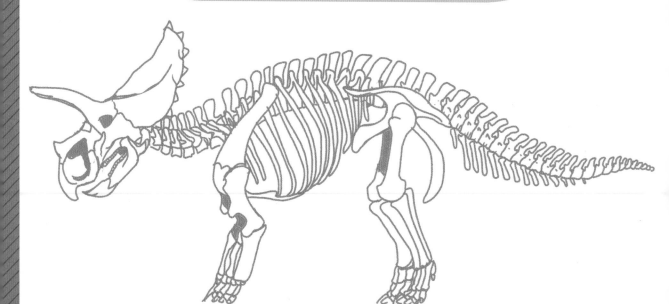

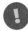 **DINO-FACT**

These were very robust creatures. The modern equivalent would be a rhinoceros. Make sure your ceratopsian has a similarly deep rib cage.

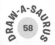

Start with a curved line as if you were drawing a hill. The high point is where the hips will go. Because ceratopsians had very short tails, the line doesn't have to be very long on the downslope.

Notice that even without the frill, the triceratops's skull is very long. Draw it facing down for eating or up for walking around.

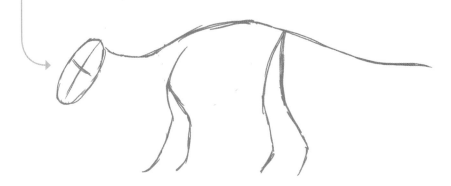

Put the figure in whatever position you like, using just lines and circles.

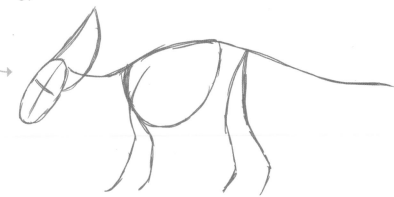

 DINO-FACT

The frill was thought to have protected the triceratops from predators. If it leaned its head all the way back, the frill would cover the entire top of its neck.

ADD TO THE TRICERATOPS

Lightly sketch the ovals around the frame.

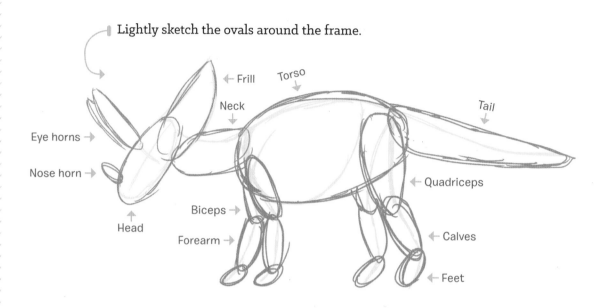

Frill
Torso
Neck
Tail
Eye horns
Nose horn
Quadriceps
Biceps
Head
Forearm
Calves
Feet

Connect the shapes and smooth the surfaces to give the triceratops its form.

Taper the end of the tail.

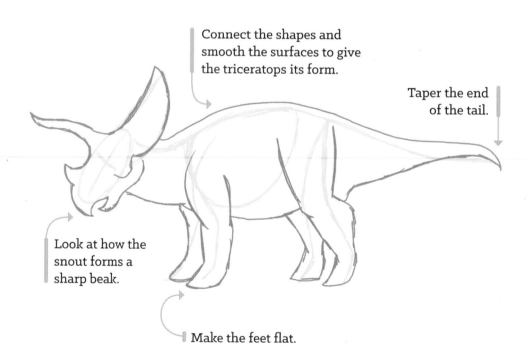

Look at how the snout forms a sharp beak.

Make the feet flat.

FLESH OUT THE TRICERATOPS

Notice that the horns protrude from the bones above the triceratops's eyes and nostrils.

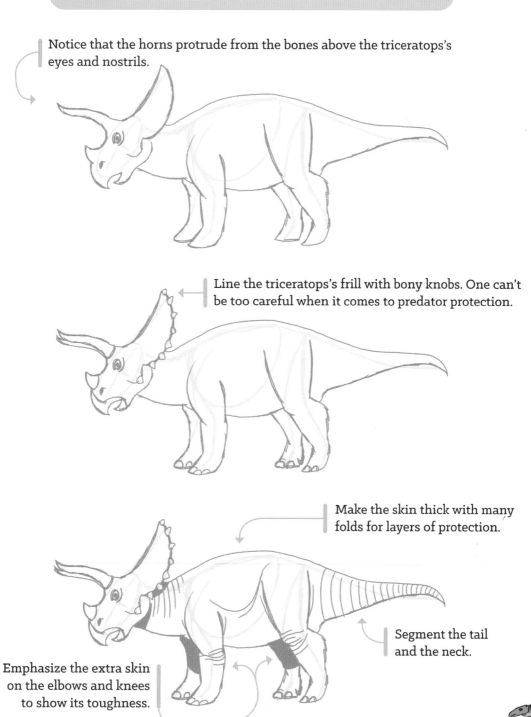

Line the triceratops's frill with bony knobs. One can't be too careful when it comes to predator protection.

Make the skin thick with many folds for layers of protection.

Segment the tail and the neck.

Emphasize the extra skin on the elbows and knees to show its toughness.

BRING THE TRICERATOPS TO LIFE

TAKE CUES FROM RHINOS

Adding texture and dimension to a triceratops is easy. As I mentioned before, the triceratops was considered the rhinoceros of its time. Look at the wrinkles and skin folds on a rhino. Also look at different kinds of rhinos. African species (left) have features different from those of the Asian types (right).

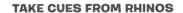

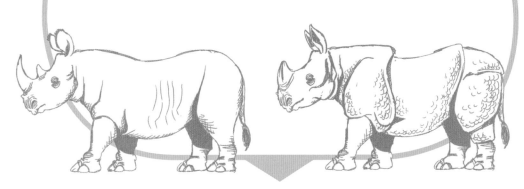

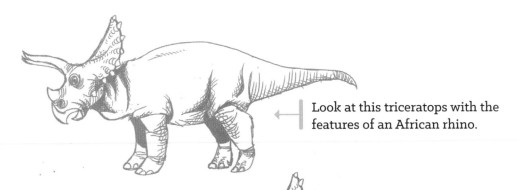

Look at this triceratops with the features of an African rhino.

Then check out this triceratops modeled on an Asian rhino.

GIVE THE TRICERATOPS SOME COLOR

The triceratops is another dinosaur that probably would not have benefited from camouflage. Its horns provided good protection on their own. More than likely the triceratops was a dull, dusty color like a rhino.

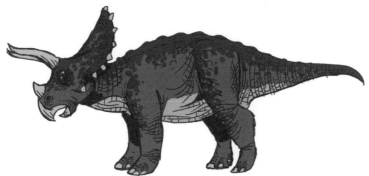

If it had any color at all, it might have been in the frill as a warning to stay away.

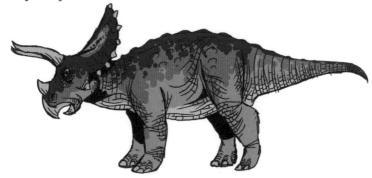

As I said, the color *alone* should have been enough of a warning.

ANGLES AND GESTURES

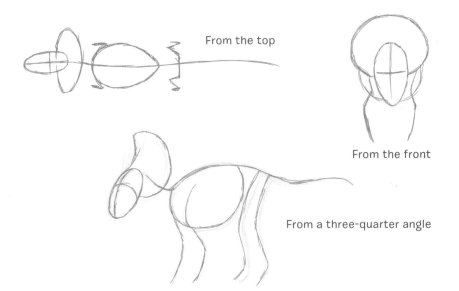

From the top

From the front

From a three-quarter angle

Now let's get this ceratopsian moving.

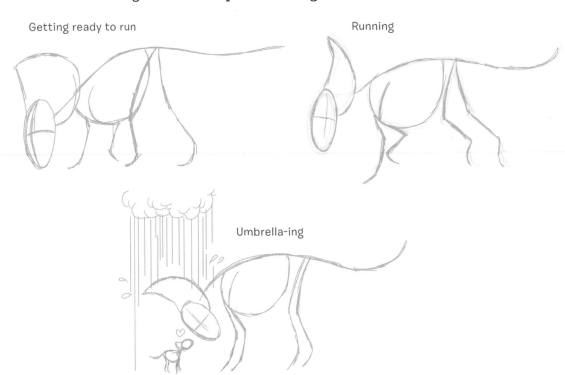

Getting ready to run

Running

Umbrella-ing

Finalizing Gesture Drawings

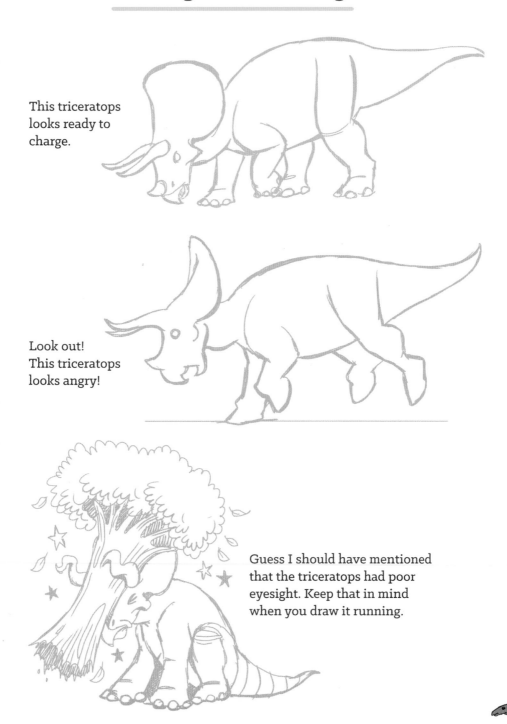

This triceratops looks ready to charge.

Look out!
This triceratops looks angry!

Guess I should have mentioned that the triceratops had poor eyesight. Keep that in mind when you draw it running.

TRICERATOPS PARTS

Curve the triceratops's horns slightly as you would for many modern animals.

Notice that the nose horn grew at the same angle.

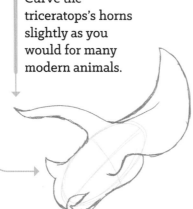

It's worthwhile to take a closer look at the triceratops's frill since there is nothing to compare with it in modern animals. The frill is part of the ceratopsian skull, making the ceratopsian skull the proportionately longest skull of any animal, living or extinct.

Although it might not have completely protected the triceratops from a predator, the frill flared out enough to cover the vulnerable neck from an attack from above. Its horns grew out of the bone directly above the eyes.

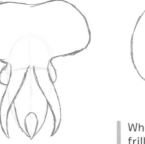

When viewed head on, the frill resembles a semicircle.

The triceratops's tail was short for a dinosaur.

The triceratops's legs were short and stocky but had enough power to enable the triceratops to hold its ground against others of its kind.

DRAWING OTHER
CERATOPSIANS

Although most ceratopsians came from
North America, a few came from Asia.

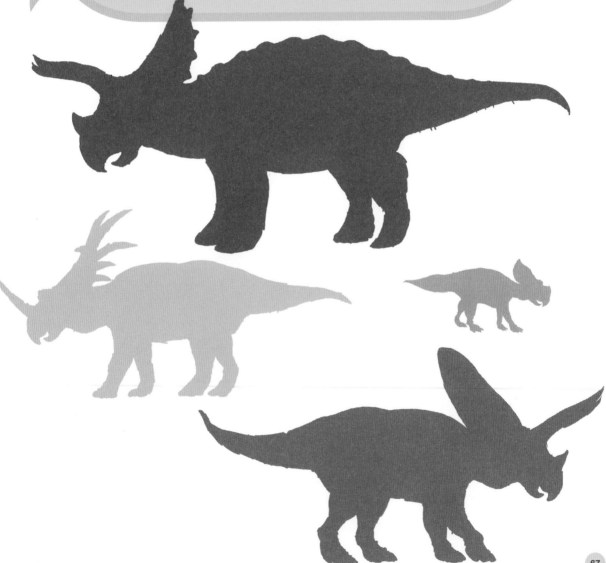

The earliest known ceratopsian was the **PROTOCERATOPS** from Mongolia. It was roughly the size of a sheep and lacked the pronounced horns of other frilled dinosaurs. It also had shorter legs than most other ceratopsians.

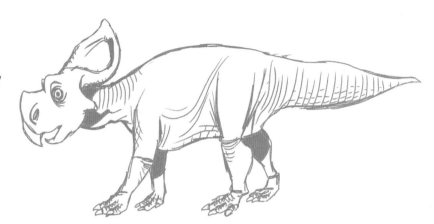

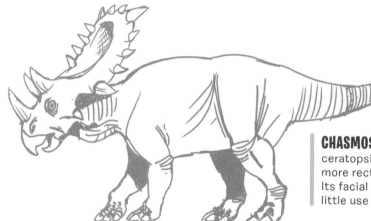

CHASMOSAURUS was a medium-size ceratopsian with a frill that was more rectangular than rounded. Its facial horns were short and of little use for hole poking.

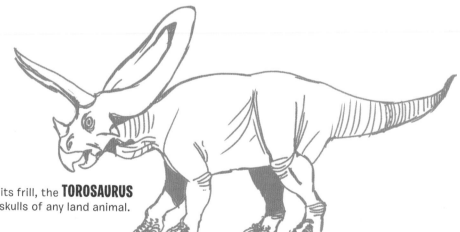

Because of the size of its frill, the **TOROSAURUS** had one of the largest skulls of any land animal. It also had long horns.

STYRACOSAURUS means "spiked lizard." Its frill had pointy bits sticking out all over the place. Its nasal horn was the longest of all ceratopsians.

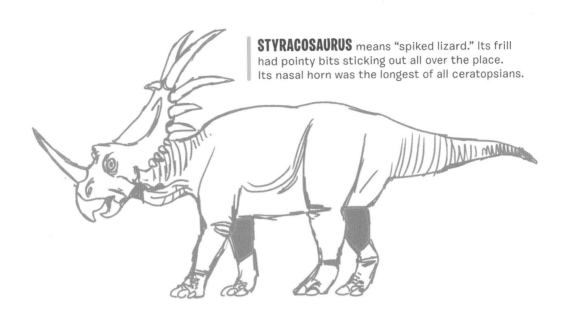

PACHYRHINOSAURUS means "big nosed—I mean thick-nosed—lizard." Fossils show that it had a large mass of bone toward its nose and above its eyes. Various horns decorated its frill.

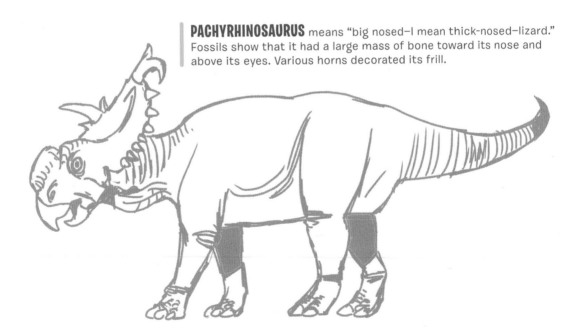

DRAW THE
ANKYLOSAURUS

Ankylosaurs were like walking armored tanks with a handy knocker on their tails. The ankylosaurus, or "fused lizard," was a great mass of plates, knobs, and spikes.

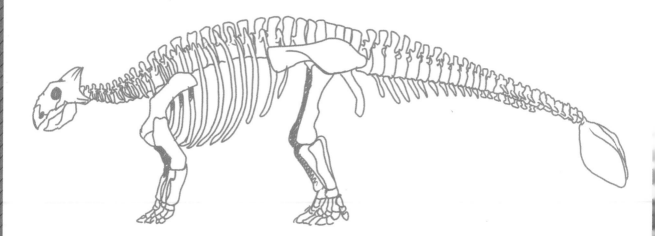

! DINO-FACT

Although not as barrel-shaped as the rest of the armored herbivores, ankylosaurus was the relatively widest dinosaur of them all.

To start, draw a hill-like line, but set the high point back just before the hips, and make the tail longer.

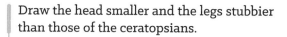

Draw the head smaller and the legs stubbier than those of the ceratopsians.

Notice the club at the end of its tail, just . . . waiting.

ADD TO THE ANKYLOSAURUS

Cover the shape with ovals to form its bulk.

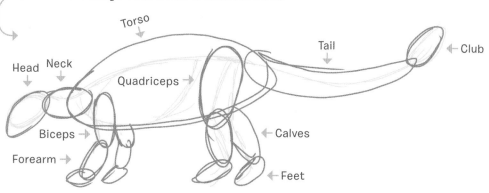

Torso

Tail

← Club

Head Neck

Quadriceps →

Biceps →

← Calves

Forearm →

← Feet

Notice that the horns form on the back of the skull.

Although ankylosaurus was a very bumpy creature, you still need to smooth out its shape.

Make all four legs very stout.

Form a beak with the mouth.

FLESH OUT THE ANKYLOSAURUS

To make your ankylosaurus drawing pop, show the segments not just on the tail but also along the entire back.

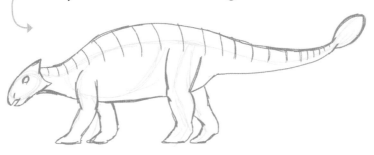

Make sure each back segment also has its own spike that protrudes straight out from the sides. This gives extra protection to the less bony underside.

Give each segment a bony knob covering the length of the back.

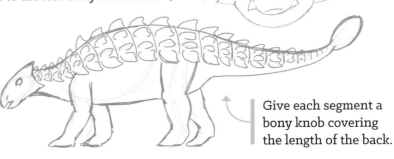

Cover the entire upper surface of the ankylosaurus in thick scales.

Give it a sharp beak for feeding.

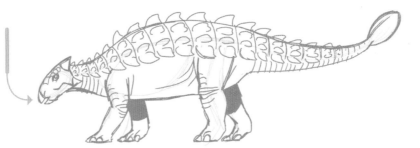

BRING THE ANKYLOSAURUS TO LIFE

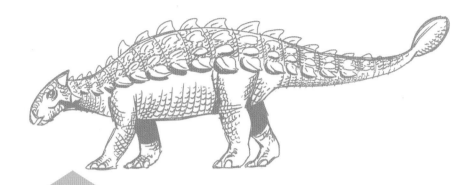

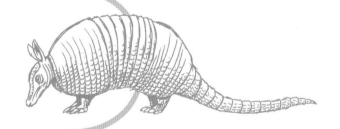

TAKE CUES FROM ARMADILLOS

An armadillo is a bit similar to the ankylosaurus, with its segmented shell. Just line the anklyosaurus drawing with bony knobs.

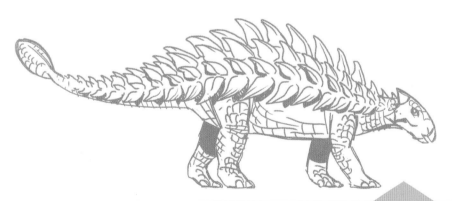

TAKE CUES FROM HEDGEHOGS

Cover the back to create a spikier, hedgehog-like look.

An ankylosaurus could have had a dull rock color to warn predators of its tough exterior.

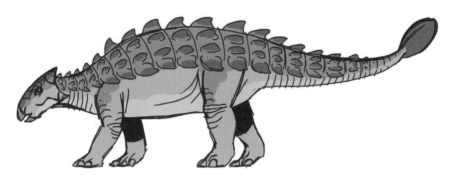

Giving each spike and knob a red point would provide further warning for potential diners.

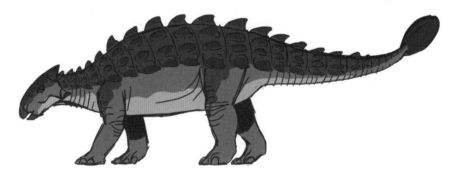

However, the ankylosaurus could have been a more sporting type.

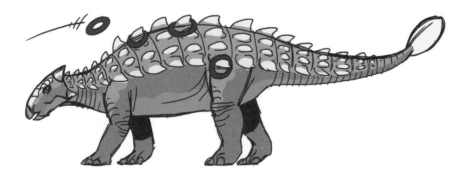

ANGLES AND GESTURES

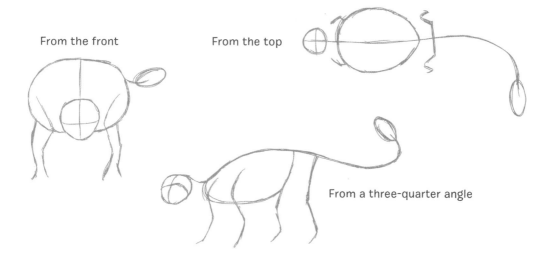

From the front

From the top

From a three-quarter angle

The ankylosaurus was not known for its speed. Most of its actions revolved around its club tail.

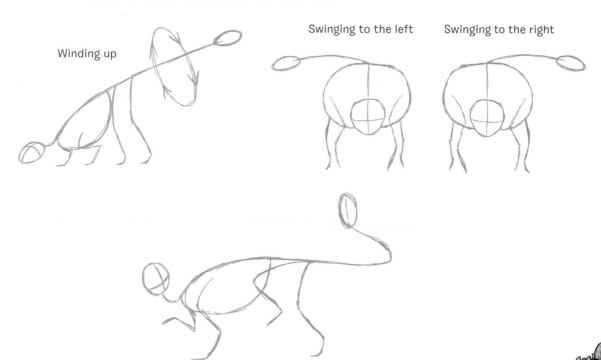

Winding up

Swinging to the left

Swinging to the right

Then you do the hokey pokey and you turn yourself around . . .
(Take out the hokey pokey. I think we have to pay to use that. —Editor)

Finalizing Gesture Drawings

Although it's a lot of work, it's time to put some life into those ankylosaurus moves.

Ready to strike.

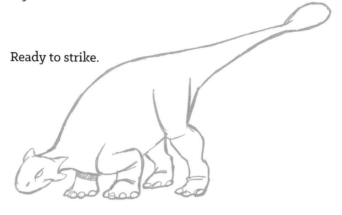

The windup . . .

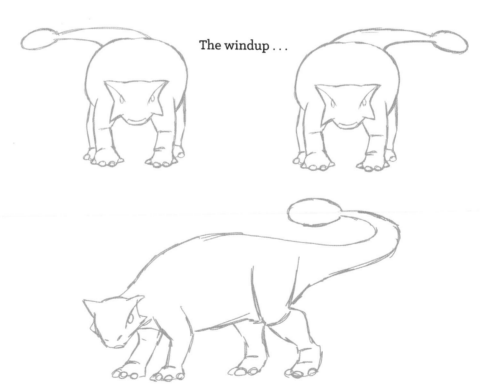

And the smack! (It's a scientific impossibility that ankylosaurus played baseball. Whack-a-Dromaeosaurus was more its game.)

ANKYLOSAURUS PARTS

The ankylosaurus's head was just as armored as the rest of its body. Bony plates on top and horns on the back formed a sort of prehistoric mullet.

The horns on its head stuck out, so its skull was wider than it was long.

Even the ankylosaurus's eyelids had a layer of bone.

The tail bones formed a stiff rod to support the weight of the club. This meant limited flexibility but more power when the tail was swung.

The torso of the ankylosaurus was a walking fortress. Its back was covered in segmented plates that were covered in bony knobs. The sides had a row of spikes that ran over the legs and underbelly.

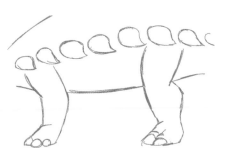

As for its legs . . . well, quite frankly, the ankylosaurus would have been better off if it had evolved tank treads instead. The legs it had were suited to getting it from point A to point B. Very slowly.

DRAWING OTHER
ANKYLOSAURS

The heavily armored ankylosaur family has been found on every continent except Africa.

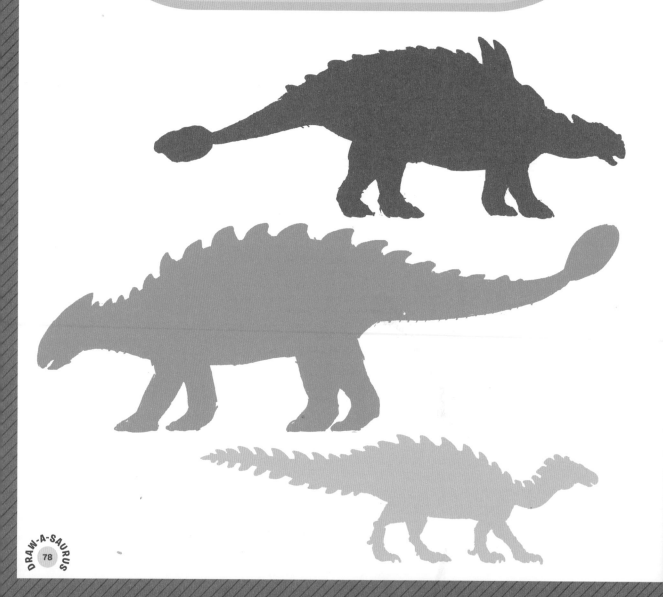

SCELIDOSAURUS was among the earliest armored dinosaurs and a distant cousin to the ankylosaurus. It had no tail club, so it defended itself by debating other dinosaurs.* It's also the oldest dinosaur found with a complete skeleton.

*"Fact" provided by Mrs. Campbell's fifth grade debate squad. They have little to no standing in the paleontological community.

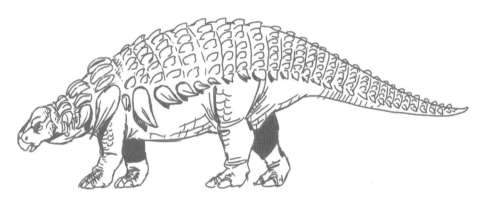

EDMONTONIA was a clubless nodosaur. Nodosaurs were ankylosaurs that were covered in knobbed, bony armor. It had large spikes that grew out of its shoulders and sides. Edmontonia's skull was thick and it had a narrow snout.

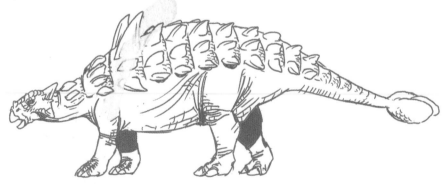

EUOPLOCEPHALUS means "well armored." Although it was smaller than the ankylosaurus, its armor and spikes were larger. The armor and spikes did not run the entire length of the tail. Some artists have shown spikes on the euoplocephalus's tail. Others have shown kittens. (Both are wrong.)

DRAW THE
STEGOSAURUS

Stegosaurs are characterized by the plates
on their backs and a tail full of spikes.

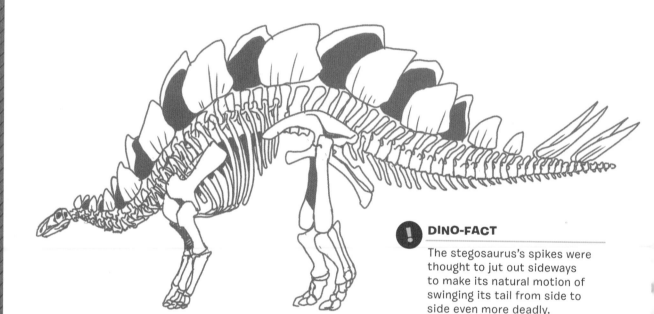

! DINO-FACT

The stegosaurus's spikes were
thought to jut out sideways
to make its natural motion of
swinging its tail from side to
side even more deadly.

! DINO-FACT

The stegosaurus had the smallest head
of all armored dinosaur types. It had
almost the same head size as a modern
horse but attached to a body that was
up to 30 feet long.

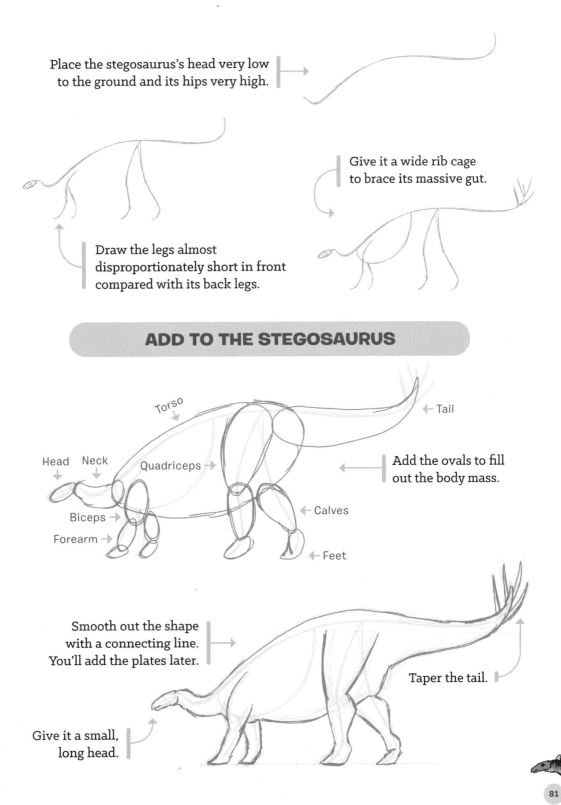

Place the stegosaurus's head very low to the ground and its hips very high.

Give it a wide rib cage to brace its massive gut.

Draw the legs almost disproportionately short in front compared with its back legs.

ADD TO THE STEGOSAURUS

Torso

Tail

Head Neck

Quadriceps

Add the ovals to fill out the body mass.

Biceps

Calves

Forearm

Feet

Smooth out the shape with a connecting line. You'll add the plates later.

Taper the tail.

Give it a small, long head.

FLESH OUT THE STEGOSAURUS

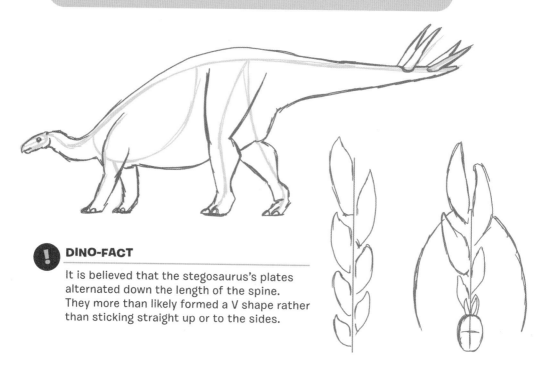

! **DINO-FACT**

It is believed that the stegosaurus's plates alternated down the length of the spine. They more than likely formed a V shape rather than sticking straight up or to the sides.

Add the most important feature—the plates. *Stegosaurus* means "roofed lizard," so think of these as dinosaur shingles. Start drawing the plates very small, just behind the head, and have them run the entire length of the back to the tail spikes.

Make the plates largest right above the hips.

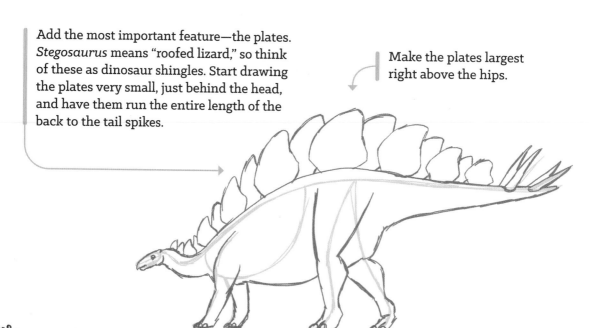

BRING THE STEGOSAURUS TO LIFE

Unless you can picture letting a lizard run loose through a combination glue/dinner plate/wooden stake factory, it's hard to imagine an animal like the stegosaurus walking the earth today.

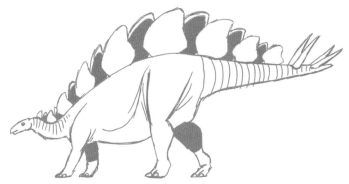

The stegosaurus had to be a hearty creature to carry the weight of its plates. The skin surrounding the plates must have been equally stout.

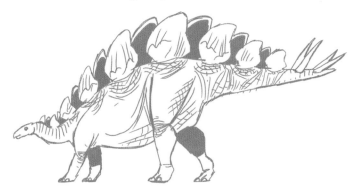

It's more than likely that its plates were for display rather than protection.

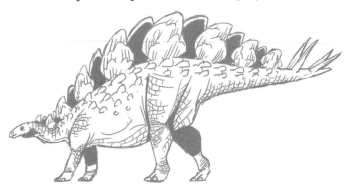

The stegosaurus could have used a bright color.

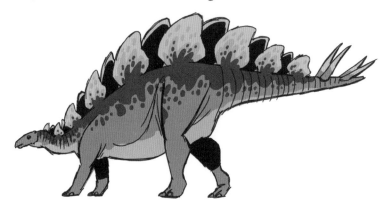

It also could have used a red color to warn predators to stay away.

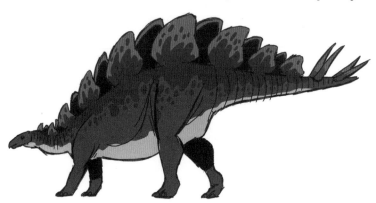

Here's the stegosaurus's coloring if the predators didn't get the message the first time . . .

From the top

From a three-quarter angle

From the front

Like the ankylosaurus, the stegosaurus's actions revolved around its tail. The stego's tail was higher up and had a larger range of motion that allowed it:

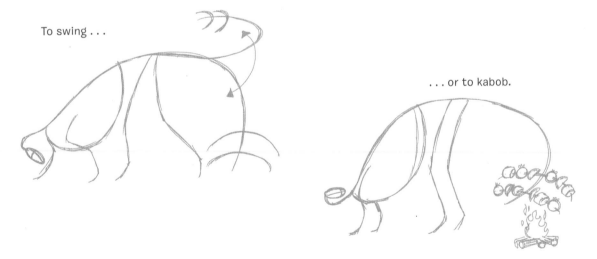

To swing . . .

. . . or to kabob.

Finalizing Gesture Drawings

Now add some life to your stegosaurus action drawings.

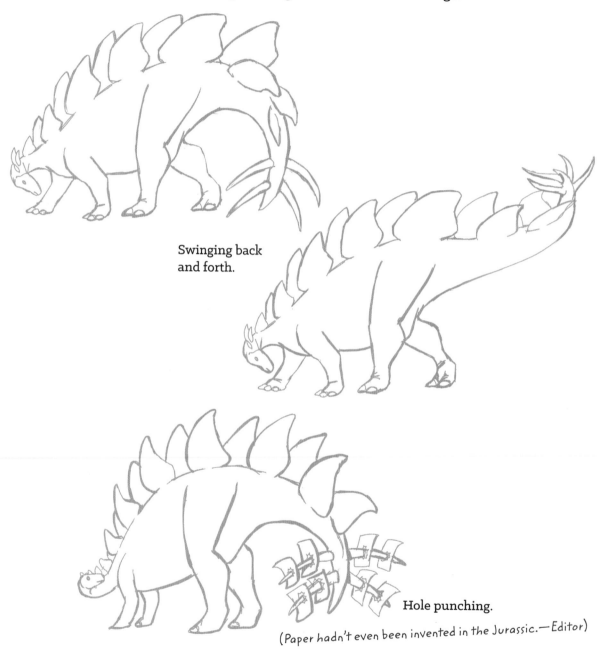

Swinging back
and forth.

Hole punching.

(Paper hadn't even been invented in the Jurassic.—Editor)

STEGOSAURUS PARTS

The stegosaurus's head was ridiculously small compared with the rest of its body. The brain inside was so small that the stegosaurus was thought to be one of the least intelligent dinosaurs. The fossil record shows that not one stegosaurus ever finished high school.

The sharp beak was used for shearing plants for food.

The spikes on the stegosaurus's tail pointed out to the sides.

The back legs were huge compared to the front. For a time it was thought that the back end had its own brain (insert your own joke here).

DRAWING OTHER
STEGOSAURS

Most stegosaurids were known for their plates and spikes.

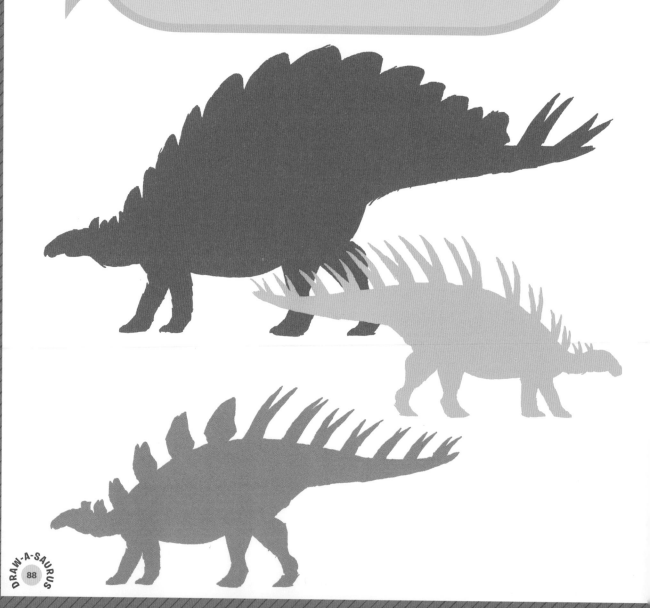

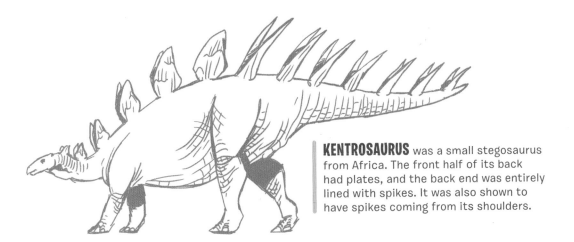

KENTROSAURUS was a small stegosaurus from Africa. The front half of its back had plates, and the back end was entirely lined with spikes. It was also shown to have spikes coming from its shoulders.

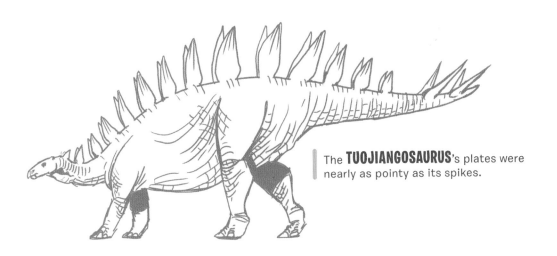

The **TUOJIANGOSAURUS**'s plates were nearly as pointy as its spikes.

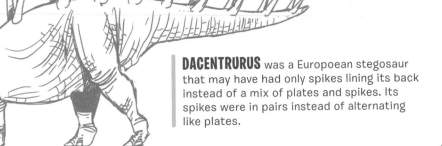

DACENTRURUS was a Europoean stegosaur that may have had only spikes lining its back instead of a mix of plates and spikes. Its spikes were in pairs instead of alternating like plates.

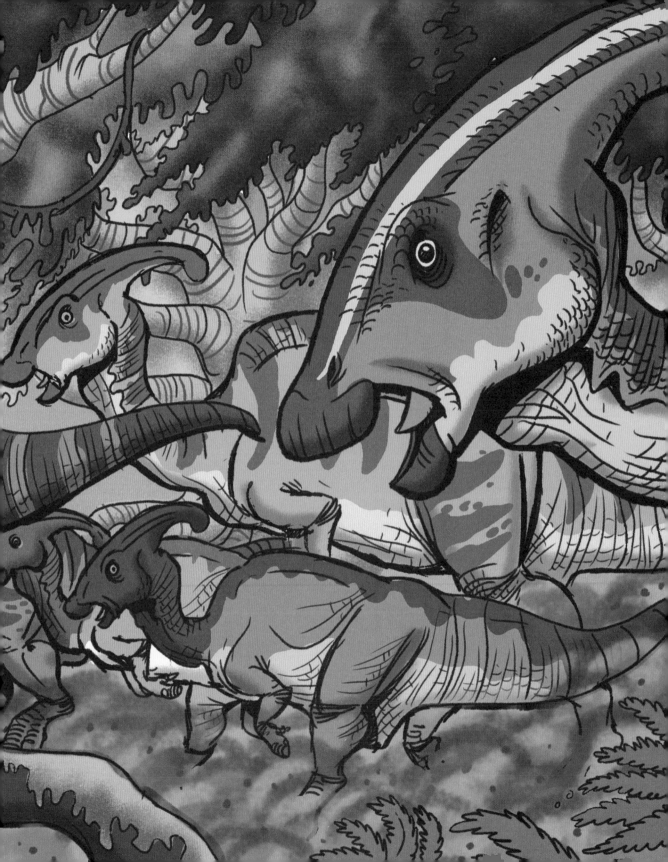

DRAWING
ORNITHOPODS

ORNITHOPODS

were **LARGE-BEAKED HERBIVORES.**
They were **UNIQUE** among all dinosaurs
because they could either walk on all
FOUR FEET or just on their **HIND LEGS.**
Ornithopod means **'BIRD FOOT.'** All these
DINOSAURS had only **THREE TOES.**

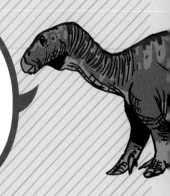

DRAW THE
HADROSAUR AND
THE IGUANODON

Both types of ornithopods had the same basic shape, with a curved neck and high hips.

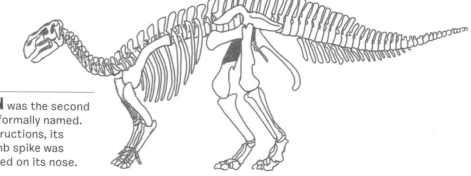

! DINO-FACT

The **IGUANODON** was the second dinosaur to be formally named. In early reconstructions, its prominent thumb spike was mistakenly placed on its nose.

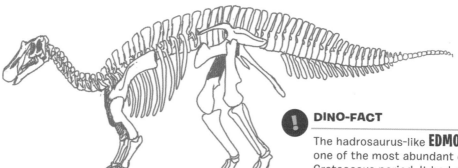

! DINO-FACT

The hadrosaurus-like **EDMONTOSAURUS** was one of the most abundant dinosaurs of the Cretaceous period. It had a wide beak that resembled a duck's bill.

To draw the basic ornithopod on all fours, start your line up high, swoop down for the neck, and go back up for the hips and tail.

Make the head smaller than that of a theropod (see page 23).

For the two-legged upright position, raise the front half off the ground.

Since the orinthopod would most likely be running in this position, tuck its arms tight to its body.

DINO-FACT

Unlike a theropod, the orinthopod's front legs were big enough to support the dinosaur on the ground.

ADD TO THE HADROSAUR AND THE IGUANODON

To draw the neck and arms, use smaller ovals than you use for the rest of the body.

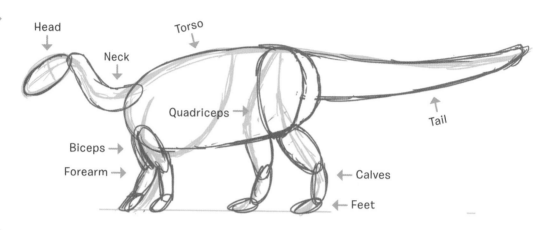

Head

Torso

Neck

Quadriceps

Tail

Biceps

Forearm

Calves

Feet

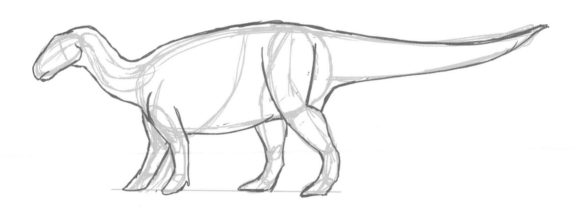

 DINO-FACT

The ornithopods were not small dinosaurs. Most hadrosaurs and iguanodons were 30 to 45 feet long.

FLESH OUT THE HADROSAUR AND THE IGUANODON

Place the eyes high and looking sideways.

Give it a small mouth.

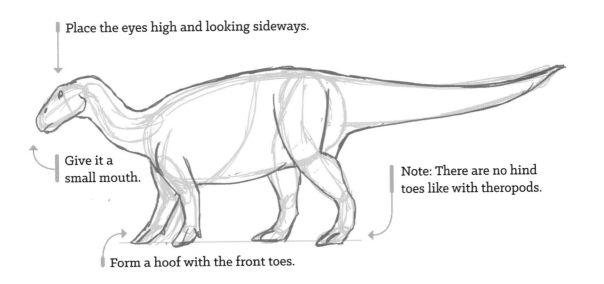

Note: There are no hind toes like with theropods.

Form a hoof with the front toes.

Make sure the tail and neck of the iguanodon are segmented.

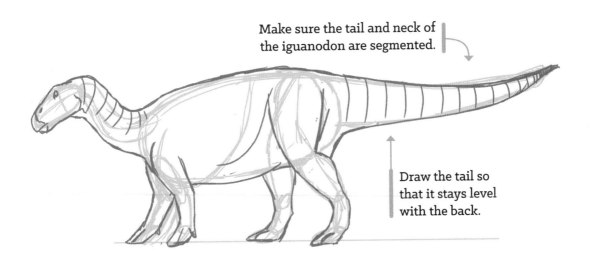

Draw the tail so that it stays level with the back.

BRING THE HADROSAUR AND THE IGUANODON TO LIFE

TAKE CUES FROM ELEPHANTS

Fossilized ornithopod skin impressions have been found along with their skeletal remains. We know they had thick, wrinkled skin with bony scales. Again, modern elephants are a good reference for your drawing. Elephants are also known as *pachyderms*, which means "thick skin."

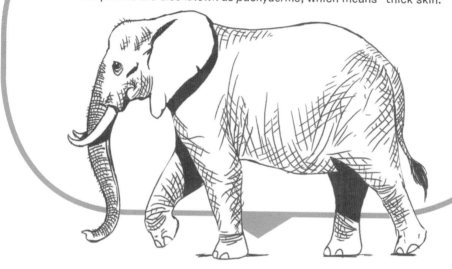

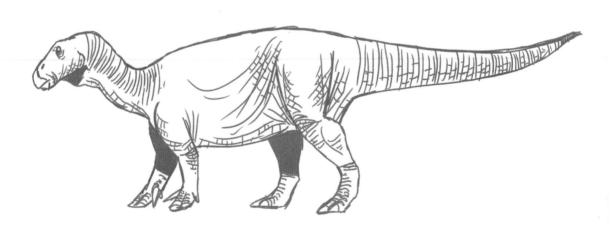

TAKE CUES FROM LIZARDS

Crocodiles and lizards are useful examples of how scales cover a body.

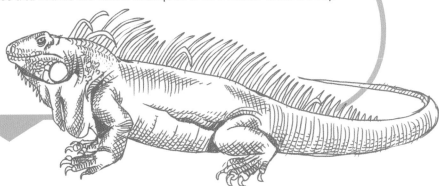

TAKE CUES FROM IGUANAS

Iguanodons were especially abundant dinosaurs. They lived in both the Jurassic and the Cretaceous periods, and their fossils have been found in nearly all parts of the world. They are so named for having iguana-like teeth.

(Not what they meant. —Editor)

GIVE THE HADROSAUR AND THE IGUANODON SOME COLOR

Because they had no natural defenses, it's likely that ornithopods had some sort of camouflage coloring.

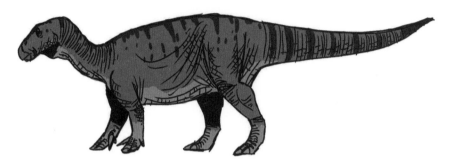

Since they had the social behavior of modern cows, they could have had the more earthy-type tones associated with cattle.

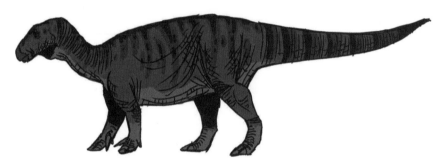

But don't get too silly!

ANGLES AND GESTURES

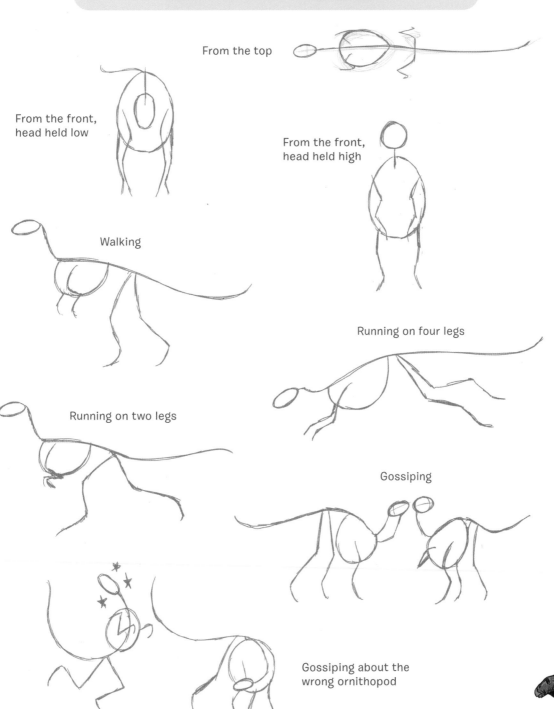

From the top

From the front, head held low

From the front, head held high

Walking

Running on four legs

Running on two legs

Gossiping

Gossiping about the wrong ornithopod

Finalizing Gesture Drawings

Give a little dimension to your active ornithopod drawings.

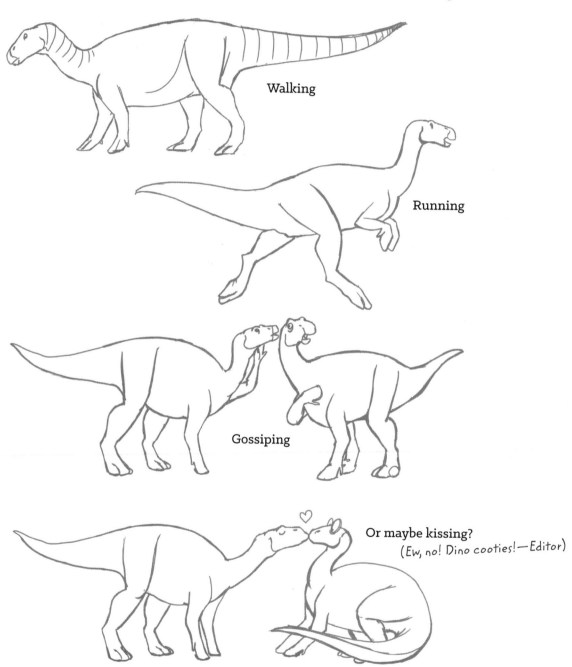

Walking

Running

Gossiping

Or maybe kissing?
(Ew, no! Dino cooties!—Editor)

HADROSAUR AND IGUANODON PARTS

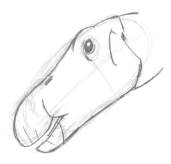

The iguanodon had a long head and a rounded beak.

The hadrosaur had a longer head, and its beak was flattened out at the end.

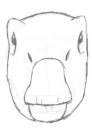

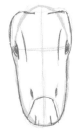

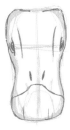

Both types of ornithopods had eyes pointing sideways.

You can draw the iguanodon's head around an oval shape.

The hadrosaur's head was more pear-shaped.

Paleontologists are divided on whether hadrosaurs actually said "quack."

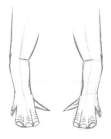

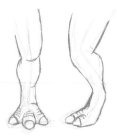

The front feet of ornithopods had fingers that fused together to form a hoof, with only the "pinkie" being able to move independently.

Additionally, an iguanodon had a "thumb spike" that could have been used to defend itself or to ruin balloon animals.

Both iguanodons and hadrosaurs were powerful and had three-toed feet like a bird.

101

DRAWING OTHER
ORNITHOPODS

Ornithopods were large dinosaurs that were thought to be the most numerous dinosaurs of the Cretaceous period.

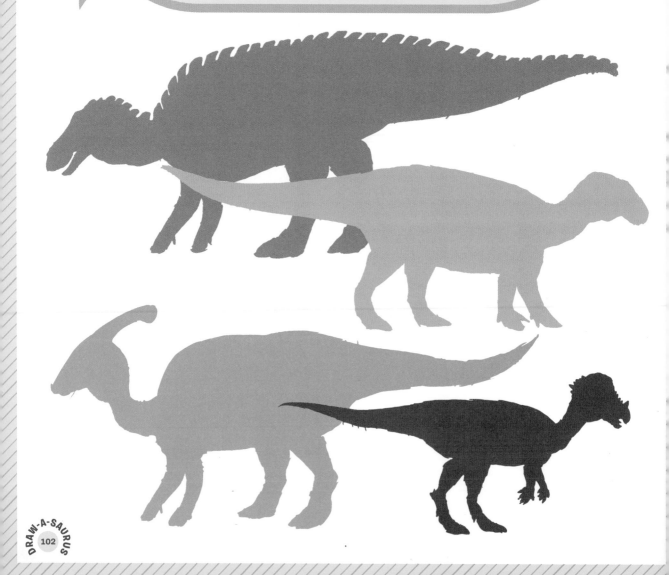

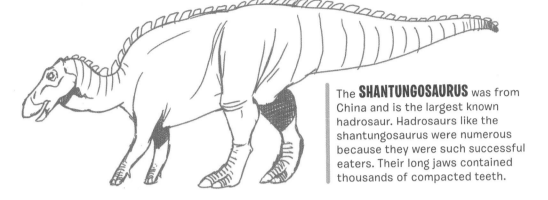

The **SHANTUNGOSAURUS** was from China and is the largest known hadrosaur. Hadrosaurs like the shantungosaurus were numerous because they were such successful eaters. Their long jaws contained thousands of compacted teeth.

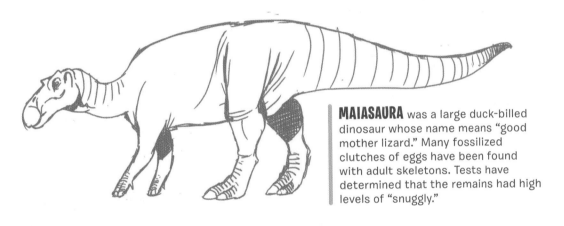

MAIASAURA was a large duck-billed dinosaur whose name means "good mother lizard." Many fossilized clutches of eggs have been found with adult skeletons. Tests have determined that the remains had high levels of "snuggly."

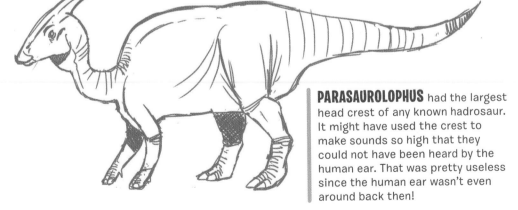

PARASAUROLOPHUS had the largest head crest of any known hadrosaur. It might have used the crest to make sounds so high that they could not have been heard by the human ear. That was pretty useless since the human ear wasn't even around back then!

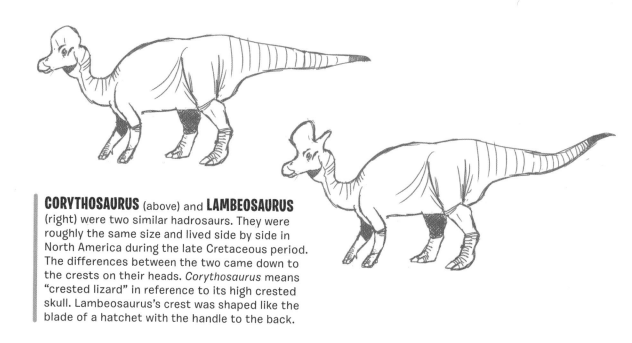

CORYTHOSAURUS (above) and **LAMBEOSAURUS** (right) were two similar hadrosaurs. They were roughly the same size and lived side by side in North America during the late Cretaceous period. The differences between the two came down to the crests on their heads. *Corythosaurus* means "crested lizard" in reference to its high crested skull. Lambeosaurus's crest was shaped like the blade of a hatchet with the handle to the back.

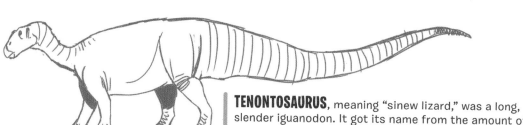

TENONTOSAURUS, meaning "sinew lizard," was a long, slender iguanodon. It got its name from the amount of tendons needed to hold up its unusually long tail.

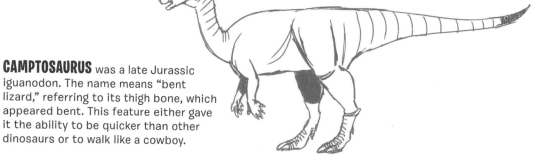

CAMPTOSAURUS was a late Jurassic iguanodon. The name means "bent lizard," referring to its thigh bone, which appeared bent. This feature either gave it the ability to be quicker than other dinosaurs or to walk like a cowboy.

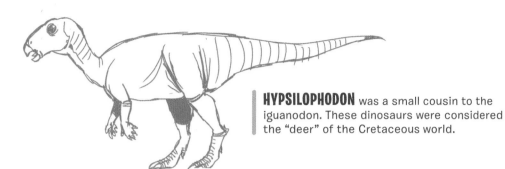

HYPSILOPHODON was a small cousin to the iguanodon. These dinosaurs were considered the "deer" of the Cretaceous world.

MUTTABURRASAURUS was a large iguanodon with a big nasal muzzle on its otherwise flat skull. Its large nose is thought to have produced distinctive sounds for communication: trumpeting for a warning, high-pitched shrieks for distress, and smooth jazz for mating.

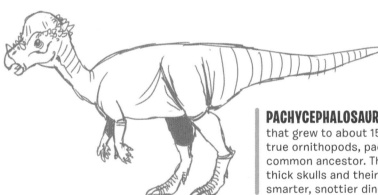

PACHYCEPHALOSAURUS was a bipedal herbivore that grew to about 15 feet long. Although not true ornithopods, pachycephalosaurs have a common ancestor. They are known for their thick skulls and their tendency to head butt the smarter, snottier dinosaurs.

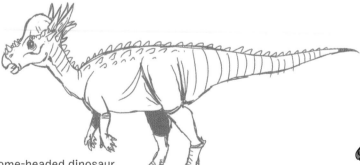

STYGIMOLOCH was a smaller dome-headed dinosaur.

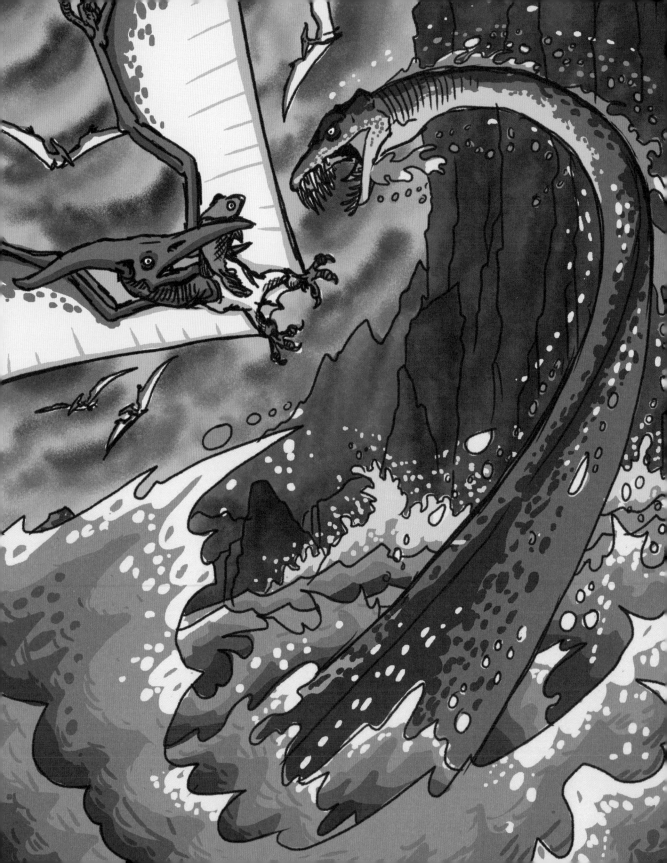

PREHISTORIC CREATURES

Not all **REPTILES** in the **MESOZOIC** were dinosaurs. What separated **FLYING REPTILES** such as the **PTERANODON** from the dinosaurs was that the fliers had neither **LIZARD HIPS** nor **BIRD HIPS**. Oh, and they also had **WINGS**.

DRAW THE
PTERANODON

Pteranodons were large reptiles but had thin, hollow bones that made them light enough to fly.

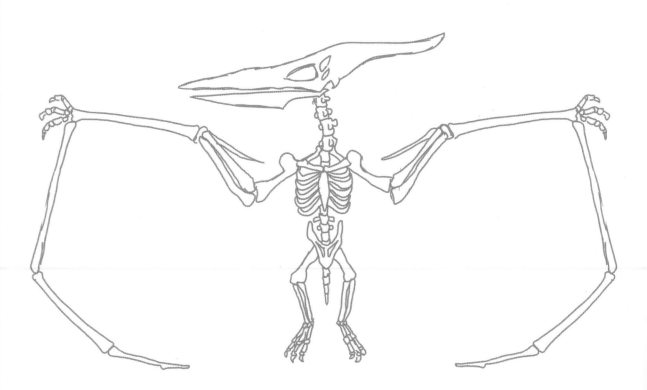

Make the head a long oval on top of the neck, and the body a thin oval right under the arms.

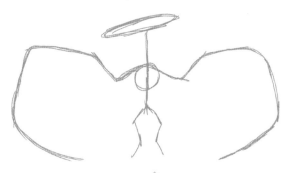

Finish with two tiny bent lines for the legs and you have your pteranodon base.

ADD TO THE PTERANODON

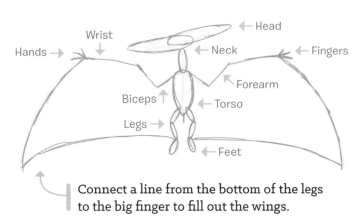

Wrist
Hands →
← Head
← Neck
← Fingers
Biceps ↑
Forearm
Legs →
← Torso
← Feet

Connect a line from the bottom of the legs to the big finger to fill out the wings.

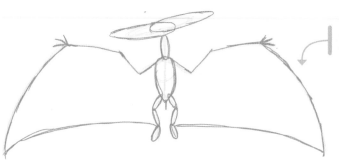

Smooth out the outline.

FLESH OUT THE PTERANODON

Make the eyes
big and bulgy.

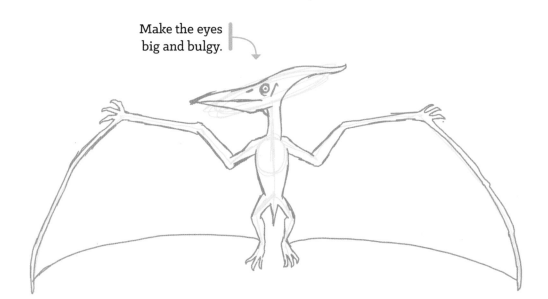

Give both the fingers
and the toes claws.

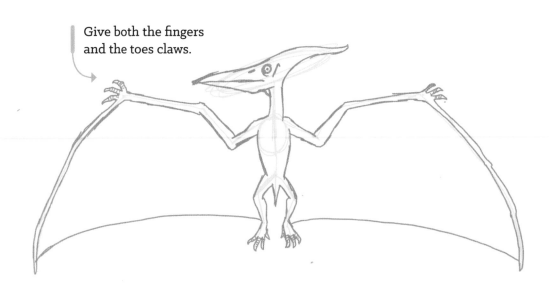

BRING THE PTERANODON TO LIFE

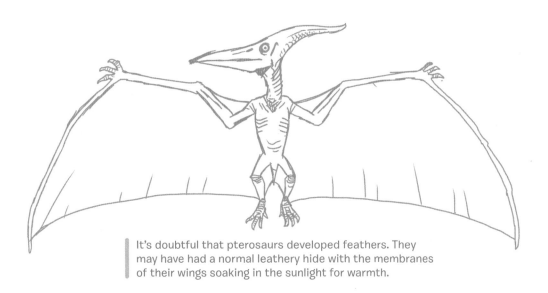

It's doubtful that pterosaurs developed feathers. They may have had a normal leathery hide with the membranes of their wings soaking in the sunlight for warmth.

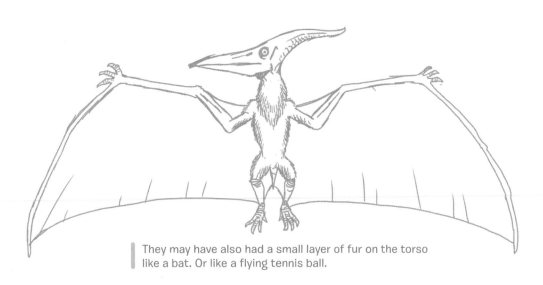

They may have also had a small layer of fur on the torso like a bat. Or like a flying tennis ball.

GIVE THE PTERANODON SOME COLOR

Pteranodons lived mostly along coastal areas and hunted fish. Therefore, it makes sense to look at modern seabirds and use their color schemes for inspiration.

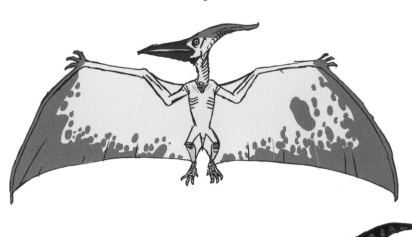

Or you could use other birds of prey.

Maybe your pteranodon is looking to earn a little cash on the side.

GESTURES

Walking

! DINO-FACT

When the pteranodon wasn't flying, it spent its time walking around on all fours. The hands and fingers of these creatures evolved to form wings. But since the legs were not sturdy enough to support the rest of a pterosaur, the hands retained their shape to aid in walking. A similar type of movement can be seen in gorillas.

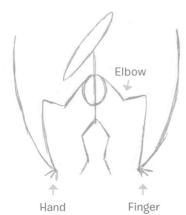

Elbow

Flying

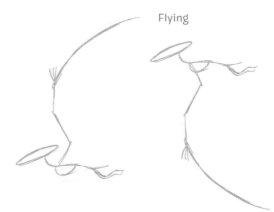

Hand Finger

! DINO-FACT

Most of the time it was thought that the pteranodon sailed through the sky by riding air currents. It was also capable of flight by flapping its wings.

Basic flying position

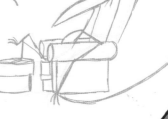

First-class flying position

Finalizing Gesture Drawings

Bring the gesture drawings to life and let your pteranodons soar.

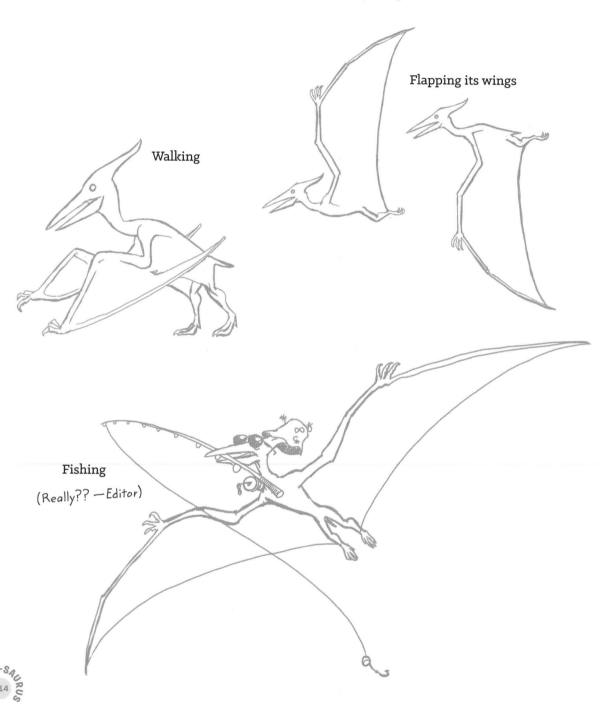

Flapping its wings

Walking

Fishing

(Really?? —Editor)

PTERANODON PARTS

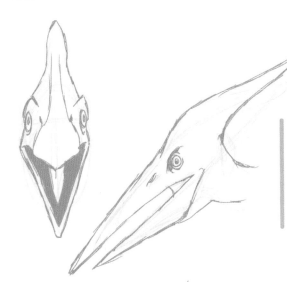

The most striking feature of the pteranodon head was the large crest coming from the back of its skull. The crest may have been used in place of cologne to attract mates.

The crest may also have been used as a rudder to aid in flight, but since the females and some other pterosaurs had little to no crest, this seems unlikely.

Wrist

Fingers →

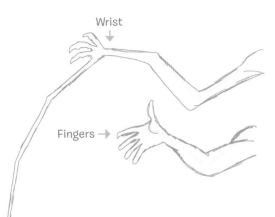

Details of the wing show how it has most of the same basic bones as the human arm. It may not help for posing, but at least you'll know how its anatomy worked.

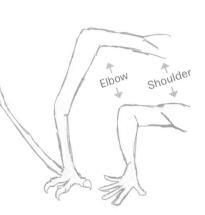

Elbow Shoulder

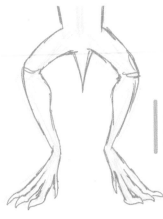

The pteranodon had a small, almost useless tail. Its legs were built like those of most dinosaurs, with the "heel" off the ground.

DRAWING OTHER
FLYING REPTILES

Other flying reptiles were all over the size chart. Some early pterosaurs were a few feet long, and some at the end of the Cretaceous were larger than a small plane.

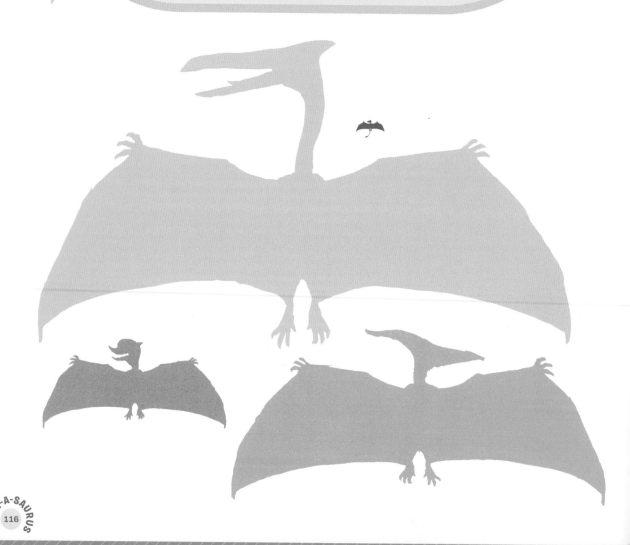

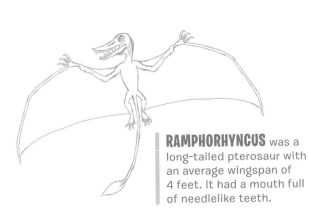

RAMPHORHYNCUS was a long-tailed pterosaur with an average wingspan of 4 feet. It had a mouth full of needlelike teeth.

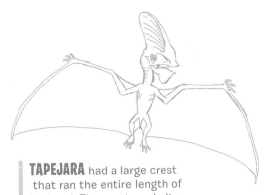

TAPEJARA had a large crest that ran the entire length of its head. The crest made its head look like a flying guitar pick.

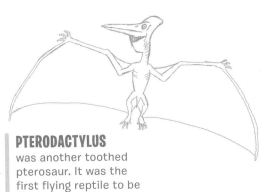

PTERODACTYLUS was another toothed pterosaur. It was the first flying reptile to be identified.

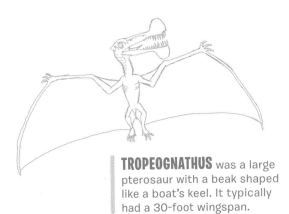

TROPEOGNATHUS was a large pterosaur with a beak shaped like a boat's keel. It typically had a 30-foot wingspan.

DIMORPHODON means "two-form tooth." It was rare among all prehistoric reptiles because it had two different types of teeth in its mouth.

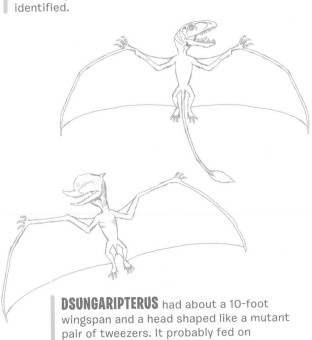

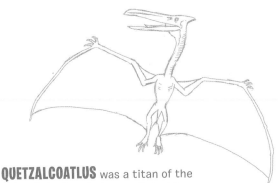

DSUNGARIPTERUS had about a 10-foot wingspan and a head shaped like a mutant pair of tweezers. It probably fed on shellfish. (And stray eyebrows.)

QUETZALCOATLUS was a titan of the skies. It had a wingspan of almost 60 feet yet may have weighed only 150 pounds. If it were alive today, it probably would feed on small cars.

DRAW THE
ELASMOSAURUS

While the pterosaurs ruled the skies, other reptiles were in command of the seas.

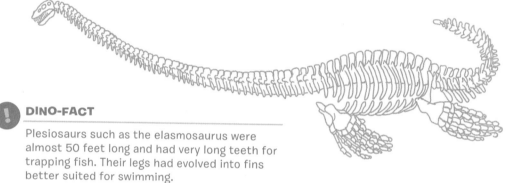

! DINO-FACT

Plesiosaurs such as the elasmosaurus were almost 50 feet long and had very long teeth for trapping fish. Their legs had evolved into fins better suited for swimming.

To draw an elasmosaurus, start with a long swooping line.

Make the head very tiny compared with the rest of the body.

Start the torso right in the final third of the body.

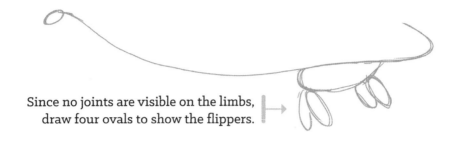

Since no joints are visible on the limbs,
draw four ovals to show the flippers.

BRING THE ELASMOSAURUS TO LIFE

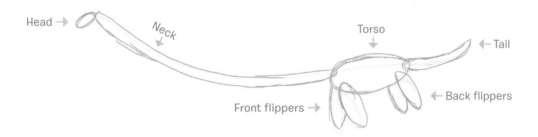

Head → Neck ↓ Torso ↓ ← Tail

Front flippers → ← Back flippers

Smooth out the ovals to achieve a dynamic shape.

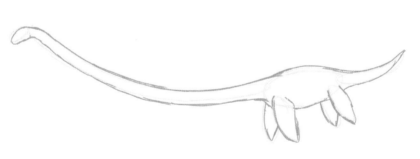

Observe that marine reptiles did not have the folds and prominent
scales that dinosaurs did.

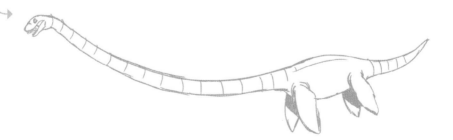

GIVE THE ELASMOSAURUS SOME COLOR

When coloring your elasmosaurus, look to existing marine life for inspiration. A barracuda hunts like an elasmosaurus, darting in and out through schools of fish. Here, the predator's camouflage changes with the appearance of refracted light (just like in a barracuda).

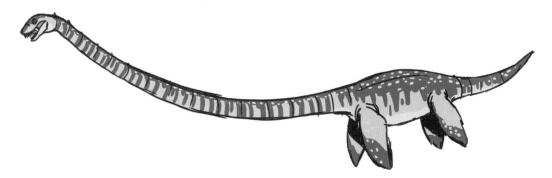

An eel is another possible inspiration for your elasmosaurus's coloring.

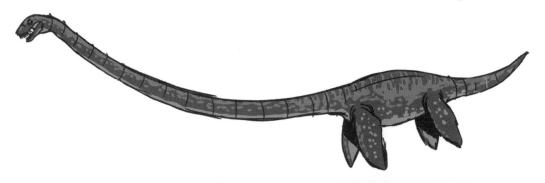

Although personally I think it would look best with a rubber ducky color scheme.

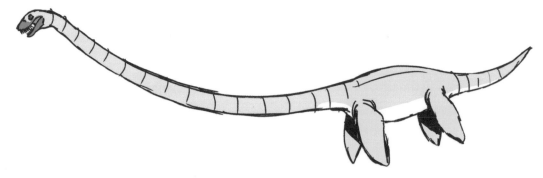

ANGLES

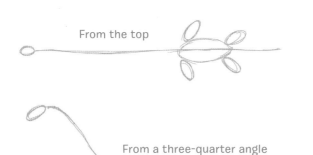

From the top

From the front

From a three-quarter angle

ELASMOSAURUS PARTS

Elasmosaurus had thin, needlelike teeth to snare fish.

Its nostrils were at the top of its head. Swimming reptiles still needed to breathe air.

Elasmosaurus could see straight ahead.

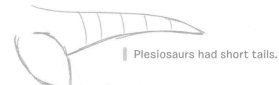

Each flipper contained hand and finger bones as leftovers from when their ancestors dwelled on land.

The front fins were generally longer than the back fins and were used for guidance as well as locomotion.

Plesiosaurs had short tails.

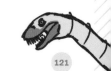

DRAW THE
TYLOSAURUS

Mosasaurs such as the tylosaurus were large predators of the sea. Unlike plesiosaurs they had very short necks and long tails.

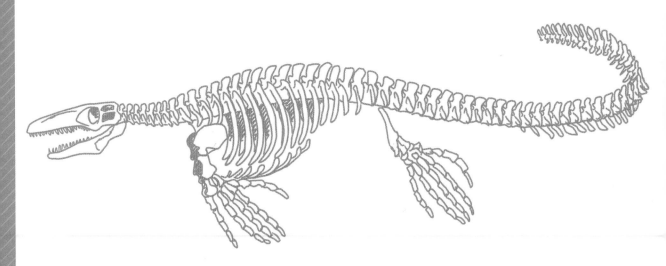

 DINO-FACT

Mosasaurs are related to modern monitor lizards such as the Komodo dragon.

Draw a single hump to begin your tylosaurus.

Make the head and torso fairly large.

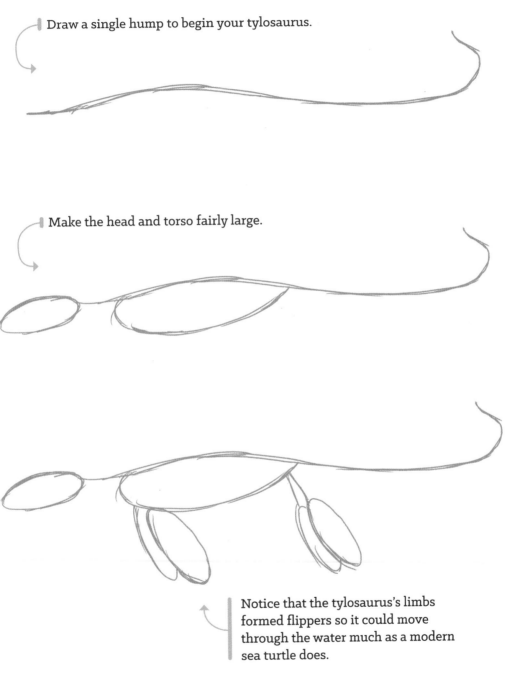

Notice that the tylosaurus's limbs formed flippers so it could move through the water much as a modern sea turtle does.

BRING THE TYLOSAURUS TO LIFE

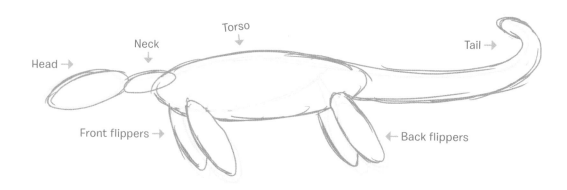

Head → Neck Torso Tail →

Front flippers → ← Back flippers

Smooth the outline to give
the tylosaurus a slick shape.

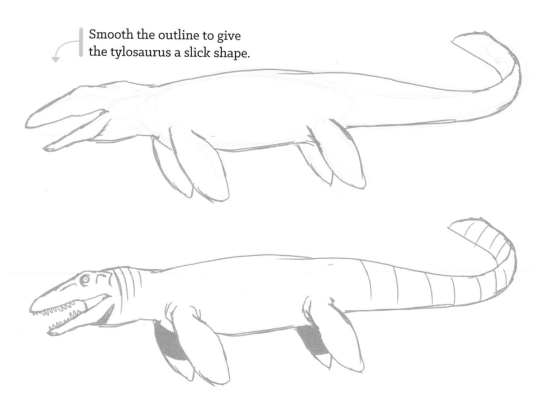

 DINO-FACT

The simple shape of the tylosaurus allowed it to move
through the water as efficiently as possible.

GIVE THE TYLOSAURUS SOME COLOR

Tylosaurus and other mosasaurs were at the top of the food chain. Look to the top predators of today's oceans for inspiration (like the orca).

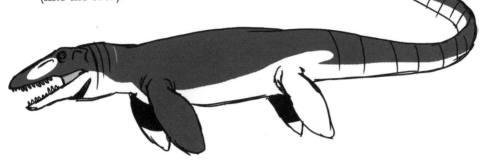

The stripes of a tiger shark would strike terror in any fish.

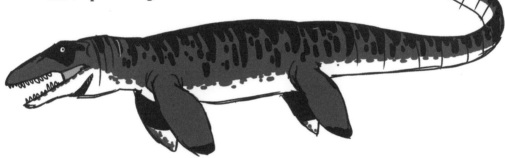

Or worse yet, look to the horrifying clownfish to inspire a sense of doom.

(Clownfish do not inspire doom. They inspire "cute.") —Editor

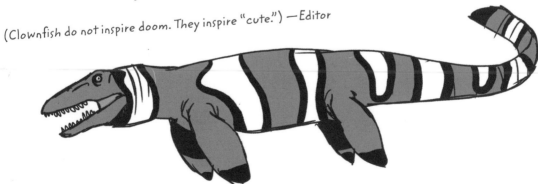

ANGLES

From the top

From the front

From a three-quarter angle

DINO-FACT

Tylosaurus was more stout than the elasmosaurus and probably the top predator of its time.

TYLOSAURUS PARTS

Tylosaurus had cone-shaped teeth for catching fish.

The head was wide and flat to help it dart though the water.

Its fins were used for propulsion and steering.

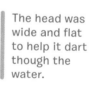
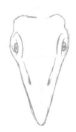

The main thrust came from the tail, as with the crocodile.

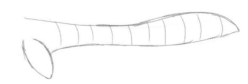

DRAWING OTHER
AQUATIC REPTILES

The Mesozoic was truly the "Age of Reptiles." Dinosaurs ruled the land. Meanwhile these and other diverse reptiles were masters of the seas.

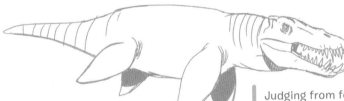

Judging from fossilized bone fragments, the **LIOPLEURODON** may have been one of the largest predators ever to exist on land or in the sea.

The **ICHTHYOSAURUS** looks like a dolphin, but it is actually a marine reptile. Ichthyosaurs were the first reptiles that were completely adapted to life in the water.

The **KRONOSAURUS** had a thinner head but was no less deadly than the liopleurodon. It was large enough to eat a shark.

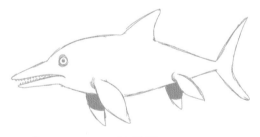

PLESIOSAURUS was like an elasmosaurus, but with a shorter neck. It was one of the earliest marine reptiles. Many people think these types of creatures are alive and well, living in a lake in Scotland. Some other people think that those folks wear their kilts a little too tight.

CHAPTER 7

FINE
TUNING

SO FAR I've given you a few basic ways to INTERPRET DINOSAURS in YOUR DRAWINGS, now it's time to get into the DETAILS.

TEXTURE

Texture is what gives a drawing its naturalism as well as its weight and dimension. When wrinkles, skin folds, scales, and even feathers are added to the exterior of your drawing, the dinosaur starts to look more like it could exist in the real world.

As an example of how to apply texture to your drawing, let's start out with a simple crisscross pattern.

Try to draw the pattern here as if it were covering your dinosaur like wrapping paper.

Ummm . . . sort of like this.

SHAPE

Instead of using it to represent a whole dinosaur, use an oval to represent a part of a dinosaur. Ovals are a good shape to work with because, like most things in nature, they have no straight edges.

You can look at an oval from any angle—you can stretch it, stand it, bend it—but you will not find a flat surface.

Much like on a dinosaur!

COMBINING SHAPES AND TEXTURES

Now it's time to cover the oval with the pattern:

If the oval were a flat shape, you would lay the pattern like this.

Since the oval is rounded on all sides, wrap the pattern around the shape.

Give it a sense of weight and gravity, with thicker lines toward the bottom of the shape.

Now try texturing the oval with a more traditional lizard-scale pattern.

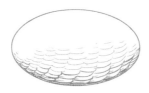

Cover larger dinosaurs in thicker, scaly folds.

Many ornithopods left fossilized skin impressions with a pebbly surface.

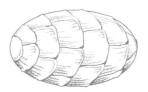

Armored dinosaurs had thick, plate-like covering patterns.

Soft feathers enveloped many ferocious theropods.

And soft, comfy pillows covered sleepy theropodzzzzzzzzzzzz.

Now apply this to one of your actual dinosaur drawings:

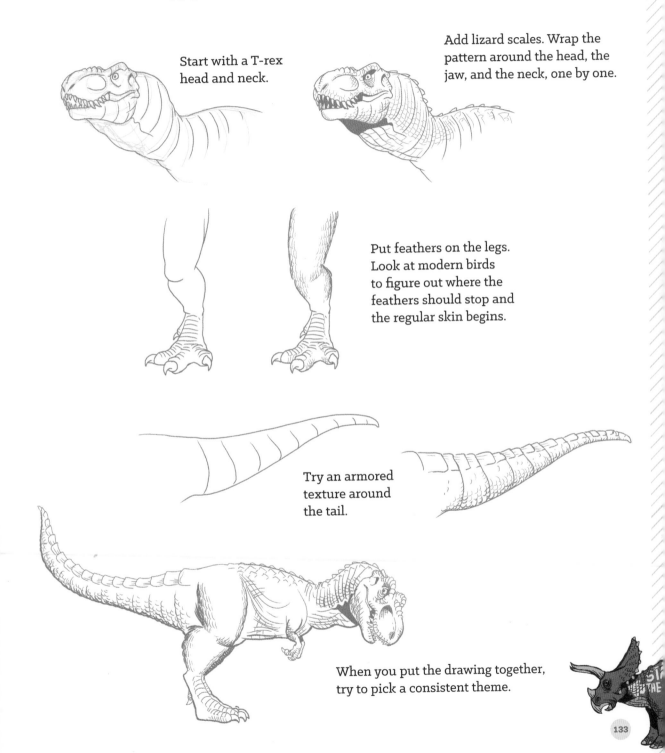

Start with a T-rex head and neck.

Add lizard scales. Wrap the pattern around the head, the jaw, and the neck, one by one.

Put feathers on the legs. Look at modern birds to figure out where the feathers should stop and the regular skin begins.

Try an armored texture around the tail.

When you put the drawing together, try to pick a consistent theme.

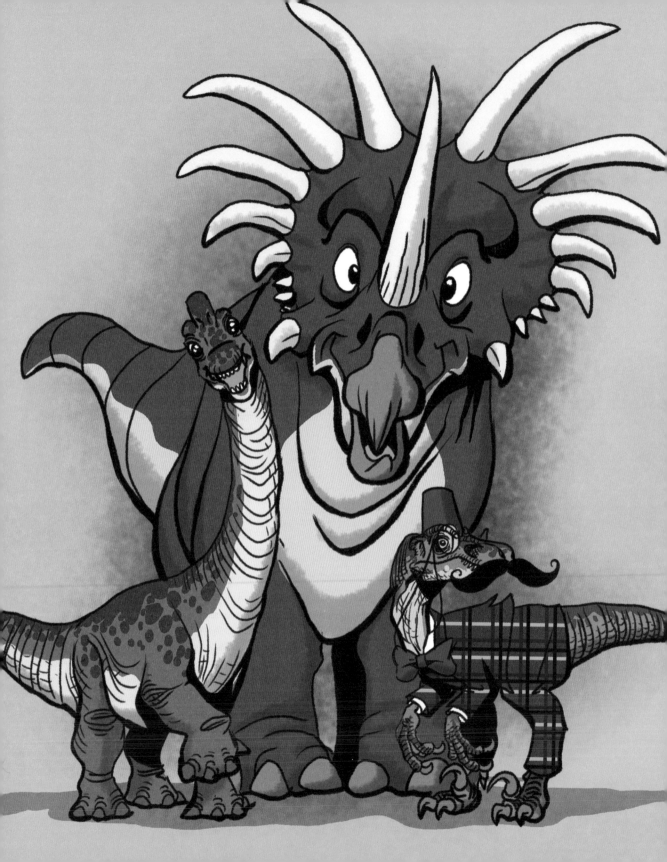

CHAPTER 8

INTERPRETATIONS

PREHISTORIC PREDATORS can resemble predators living in the **PRESENT,** and the **GIANT SAUROPODS** of the **PAST** can reflect the look of the land giants of the **MODERN AFRICAN** plains.

But **WHY STOP THERE?**

No one has seen or ever will see a living dinosaur. It is truly up to the artist drawing them to interpret how they should look. Let's say you like the Tyrannosaurus rex featured earlier in the book (page 22), but you want to take it a step further.

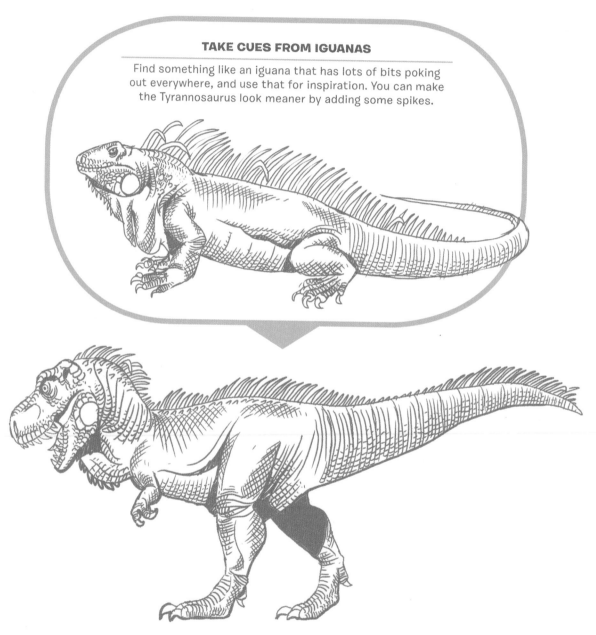

TAKE CUES FROM IGUANAS

Find something like an iguana that has lots of bits poking out everywhere, and use that for inspiration. You can make the Tyrannosaurus look meaner by adding some spikes.

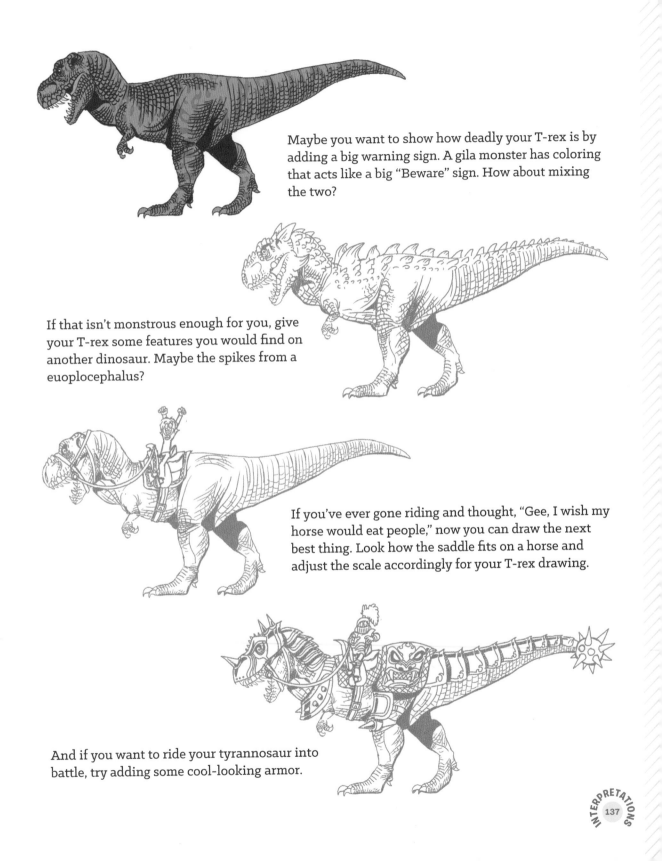

Maybe you want to show how deadly your T-rex is by adding a big warning sign. A gila monster has coloring that acts like a big "Beware" sign. How about mixing the two?

If that isn't monstrous enough for you, give your T-rex some features you would find on another dinosaur. Maybe the spikes from a euoplocephalus?

If you've ever gone riding and thought, "Gee, I wish my horse would eat people," now you can draw the next best thing. Look how the saddle fits on a horse and adjust the scale accordingly for your T-rex drawing.

And if you want to ride your tyrannosaur into battle, try adding some cool-looking armor.

CARTOON YOUR DINOSAUR

If scary dinosaurs aren't your thing, you might want to try a happy cartoon dinosaur.

Start with the basic frame, but outline the body to make it softer and rounder.

Add some chubby digits.

Make the eyes round and silly.

You can draw teeth and claws that are less threatening.

If you want to caricature your dinosaur even further, start with the basic form but choose one or two aspects to exaggerate.

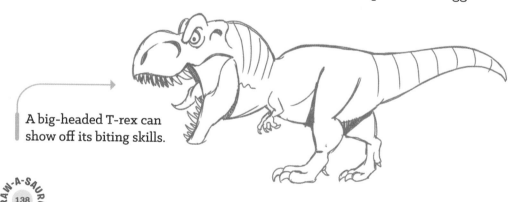

A big-headed T-rex can show off its biting skills.

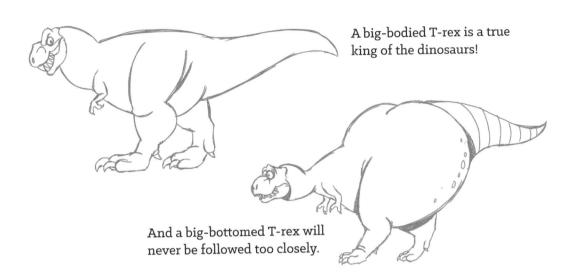

A big-bodied T-rex is a true king of the dinosaurs!

And a big-bottomed T-rex will never be followed too closely.

Other Dinosaurs

You can caricature any dinosaur in any way you want. Use your imagination and have fun.

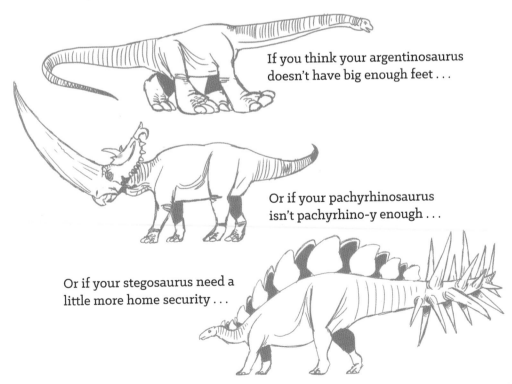

If you think your argentinosaurus doesn't have big enough feet . . .

Or if your pachyrhinosaurus isn't pachyrhino-y enough . . .

Or if your stegosaurus need a little more home security . . .

BABY DINOSAURS

What's cuter than a dog? A puppy. What's cuter than a cat? A kitten. What's cuter than Uncle Phil? Uncle Phil when he was a baby.

Everything was cuter when it was brand new. Including dinosaurs (and Uncle Phil).

How do we know what dinosaurs looked like as babies? Well, outside of a few fossils, we don't. But most animals have a pattern of features that cross species when they are young: big eyes, big heads, tiny limbs, and tiny digits. We'll just go out on a limb and say this is probably the pattern followed by baby dinosaurs as well.

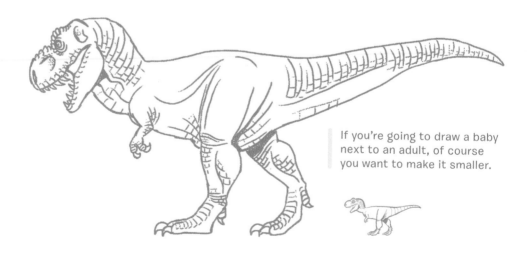

If you're going to draw a baby next to an adult, of course you want to make it smaller.

Proportion your line and circle drawing by using these baby T-rex guidelines; give it a large head, large eyes, and make everything else smaller.

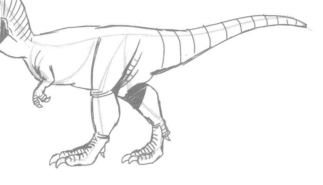

The same approach applies to other types of dinosaurs, with a few extra notes.

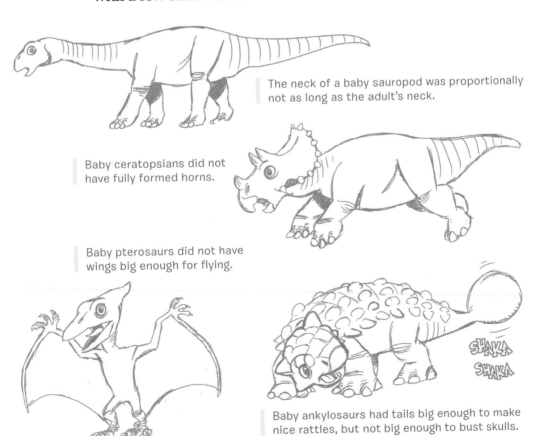

The neck of a baby sauropod was proportionally not as long as the adult's neck.

Baby ceratopsians did not have fully formed horns.

Baby pterosaurs did not have wings big enough for flying.

SHAKA
SHAKA

Baby ankylosaurs had tails big enough to make nice rattles, but not big enough to bust skulls.

CHAPTER 9

ENVIRONMENTS

So you **KNOW** how to **DRAW DINOSAURS**. **NOW** you need to **LEARN** where to **PUT 'EM.**

Again, remember, it's your drawing. If you want to draw a parasaurolophus at the mall or a deinonychus under your sister's bed, it's up to you. But if you want to try to draw dinosaurs in a more natural environment, keep reading.

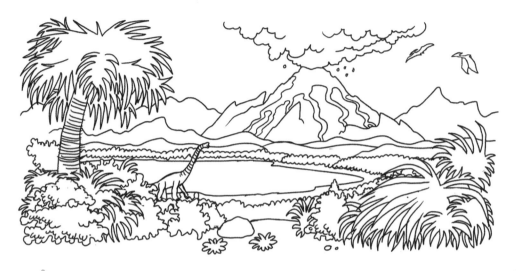

The dinosaur's world was pretty much the same as ours: plants, water, rocks. The temperatures were much different, though. The earth was still evolving into the world we know now.

While forming its shape, the earth was a big molten rock teeming with volcanic activity.

Then the water cooled things off a bit.

The earth had slowly been taking shape over billions of years by the time the dinosaurs came around. The time of the dinosaurs was known as the Mesozoic era and took place between 252 million and 65 million years ago. The Mesozoic era was divided into three periods.

The **TRIASSIC** period was 250 million to 201 million years ago. The only land was the giant continent of Pangea. The atmosphere was dry and warm, and the landscape was covered in palm and pine trees. This period ended with a mass extinction event that probably was caused by volcanic activity.

The **JURASSIC** period was from 201 million to 145 million years ago. Pangea had broken up into the continents of Laurasia and Gondwana. The earth was dominated by rain forests, and ferns were the main source of food for herbivores.

The **CRETACEOUS** period was from 145 million to 65 million years ago and marked the end of the dinosaurs. The rising seas helped divide the continents even further. The first flowering plants appeared. It is thought a massive meteor crashed into the earth, ending the Mesozoic era, killing the dinosaurs, and making the world safe for a coffee shop on every corner.

DRAWING THE ENVIRONMENT

To put your dinosaur into a Mesozoic environment, start with it standing on a bit of land for the foreground.

To give the scene some dimension, add some hills or a body of water to the background.

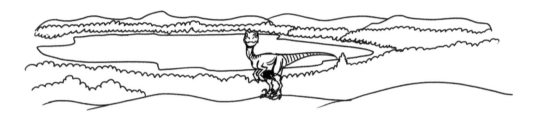

Instead of planes, add flying reptiles in the sky for authenticity.

Finish the horizon with a mountain range or a volcano.

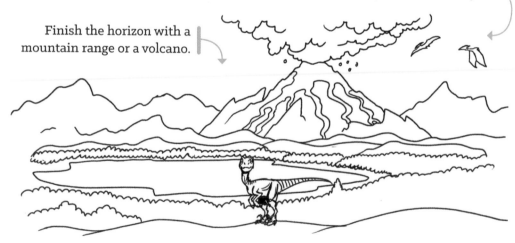

Start adding trees and other foliage to the area where the dinosaur is standing.

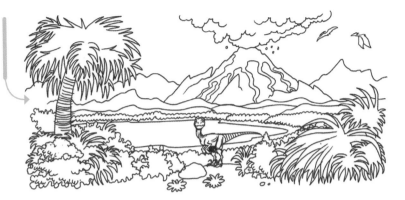

Add other dinosaurs to make an all-around atmospheric piece. Be aware of the space. Even larger dinosaurs will appear smaller the farther back they are.

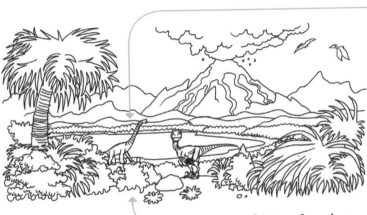

Use a few plants and rocks in the front to really bring the drawing to life.

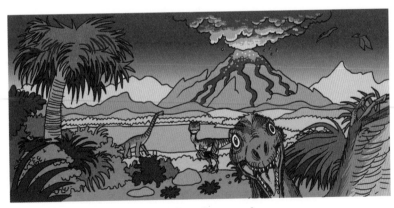

Be aware that a photobombing archaeopteryx will often appear and ruin your drawing.

Other Environments

Remember, this is a drawing from your imagination. You don't have to draw your dinosaur in the Mesozoic jungle.

You can draw it in your neighborhood . . .

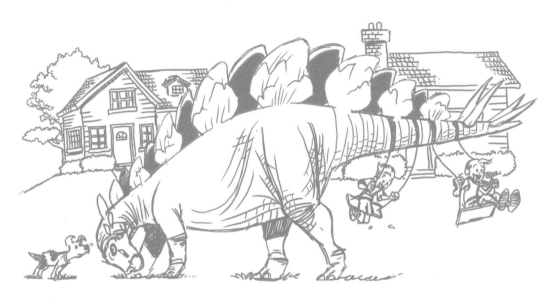

At the ball game . . .

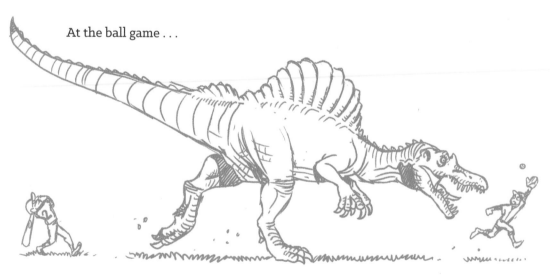

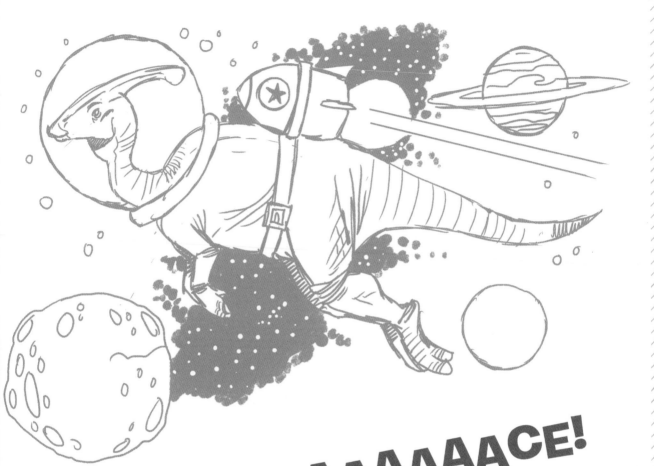

OR IN **SPAAAAAAACE!**

CONCLUSION

Now that you've learned about dinosaurs and how to draw them, the rest is up to you. Take what you've learned and draw dinosaurs the way you want to.

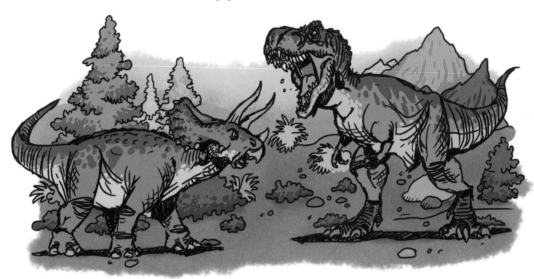

If you want to draw a tyrannosaurus fighting a triceratops on the plains of the Cretaceous period . . .

. . . or a brachiosaurus and an allosaurus dancing *Swan Lake* on a giant ladybug, *you can!* The choice is up to you.

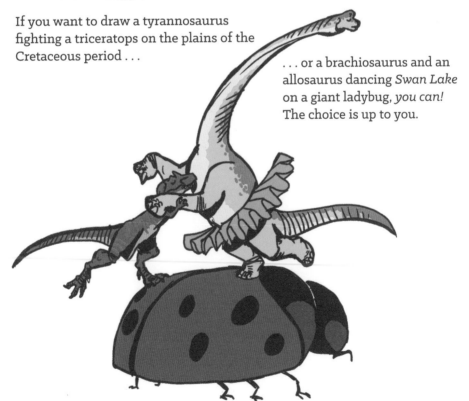

INDEX

Published in the United States by Watson-Guptill Publications, an imprint of the Crown Publishing
Group, a division of Random House LLC, a Penguin Random House Company, New York.
www.crownpublishing.com
www.watsonguptill.com

WATSON-GUPTILL and the WG and Horse designs are registered trademarks of Random House LLC

Library of Congress Cataloging-in-Publication Data

Silvani, James.
 Draw-a-saurus : everything you need to know to draw your favorite dinosaurs / James Silvani.
 pages cm
 ISBN 978-0-385-34580-4 (hardback) — ISBN 978-0-385-34581-1 (ebook)
1. Dinosaurs in art—Juvenile literature. 2. Drawing—Technique—Juvenile literature. I. Title.
 NC825.D56S55 2014
 743.6—dc23

 2014003420

Trade paperback ISBN: 978-0-385-34580-4
eBook ISBN: 978-0-385-34581-1

Printed in China

Design by Betsy Stromberg
Production by Howie Severson

10 9 8 7 6 5 4 3 2 1

First Edition